Historic
AMUSEMENT PARKS
of LONG ISLAND

HAMPTON BAYS PUBLIC LIBRARY
52 PONQUOGUE AVENUE
HAMPTON BAYS, NY 11946

AMUSEMENT PARKS of LONG ISLAND

118 Miles of Memories

Marisa L. Berman

Published by The History Press
Charleston, SC 29403
www.historypress.net

Copyright © 2015 by Marisa L. Berman
All rights reserved

Front cover, main image: Playland Park. *Courtesy of the Freeport Historical Society.*
Small image: Wonder Wheel postcard. *Author's collection.*

Back cover: Massapequa Zoo pennant. *Collection of Gary Hammond. Left image*: Painting of Cross Bay Amusement Park by Madeline Lovallo. *madelinesstudio.artistwebsites.com.*
Right image: Lollipop Farm. *Courtesy of the Society for the Preservation of Long Island Antiquities.*

First published 2015

Manufactured in the United States

ISBN 978.1.62619.448.9

Library of Congress Control Number: 2015934349

Notice: The information in this book is true and complete to the best of our knowledge. It is offered without guarantee on the part of the author or The History Press. The author and The History Press disclaim all liability in connection with the use of this book.

All rights reserved. No part of this book may be reproduced or transmitted in any form whatsoever without prior written permission from the publisher except in the case of brief quotations embodied in critical articles and reviews.

*To loved ones who lost some memories along the way.
Gert, Joan and Bobby—I will remember for you.*

CONTENTS

Foreword, by Todd Berkun	9
Acknowledgements	11
Introduction. Amusement Parks on Long Island	13

1. Brooklyn Parks

Fairyland Kiddie Park (Buddy's Fairyland), Canarsie	21
McCullough's Kiddie Parks, Coney Island	26
Nellie Bly Amusement Park / Adventurers Family Entertainment Center, Bensonhurst	27
Peter Pan Playland, Sheepshead Bay	31
Ward's Kiddie Park / Deno's Wonder Wheel Park, Coney Island	32
Wonderland / Astroland Kiddie Park, Coney Island	36

2. Queens Parks

Adventurers Inn / Great Adventure Amusement Park, Flushing	41
Auer's Kiddie Park, Rockaway Beach	45
Fairyland Park, Elmhurst	47
Joytown / Rockaways' Playland Kiddie Annex, Rockaway Beach	52
Kiddy City, Douglaston	55
Kiddie Park / Dreamland Kiddie Park, Fresh Meadows	56
Nunley's Rockaway Beach and Broad Channel Amusements, Broad Channel	58
Playland Center / Cross Bay Amusement Park, Howard Beach	61
Wonderland Farm Zoo, Ozone Park	63

Contents

3. Nassau Parks

Adventureland, Farmingdale	65
Frank Buck's Jungle Camp / Massapequa Zoo and Kiddie Park, Massapequa	67
Gruberg Funland / Gruberg's Playland, Long Beach	72
Kiddie Funland, Farmingdale	77
Kiddie Haven / Garden Amusements (McGinnis's), Garden City Park	78
Lollipop Farm, Syosset	82
Nunley's Amusement Park, Baldwin	88
Nunley's Happyland / Smiley's Happyland (Jolly Rogers), Bethpage	94
Playland Park, Freeport	99
Roadside Rest Kiddieland / Kiddieland Park / Jazzbo-Land, Oceanside	102
Spaceland, Carle Place	105

4. Suffolk Parks

Bay Shore Amusement Park, Bay Shore	111
Dodge City, Patchogue	112
Fairyland at Harvey's, Huntington	115
Fairytown, USA, Middle Island	116
Frontier City, Amityville	119
Turner's Amusement Park, Lake Ronkonkoma	122

Conclusion. Kiddie Amusements Today	125
Notes	129
Bibliography	131
Index	135
About the Author	139

FOREWORD

When we look at how Long Island has evolved over the years, it's hard to miss that much of the local entertainment we once enjoyed as kids is no longer around. There are fewer bowling alleys, golf ranges, arcades, drive-in movie theaters, diners and, perhaps most noticeably of all, amusement parks. At one time, there seemed to be a park in almost every neighborhood. If you had a birthday party, a free weekend day or even a few hours in the afternoon, you could head on over to the local amusement park for guaranteed enjoyment.

We might have persuaded our parents to take us to our favorite park or at least to the nearest one. At a quarter or so for each ride, we could tell them the outing wouldn't be too expensive. Each park had its own unique personality, its own specialty and its own age group to which it catered. Most had restaurants or arcades on or near the grounds that seemed to be as much a part of the venue as the amusement parks themselves.

We can speculate about why there are fewer parks around today. Perhaps there are fewer young people; maybe more of them stay home and play computer games or do organized sports. There is less open land on which to put these parks today. The island is more crowded and its real estate more expensive. We still have Adventureland in Farmingdale and Splish Splash in Coram, but in general, there is less local entertainment on Long Island than there once was.

For a long time, it seemed as if our individual amusement park experiences were memories we would never visit again. Some Internet sites came along

Foreword

attempting to recapture our memories, but then, in the late 2000s, Facebook took hold and gave us a meeting place where we could, from almost anywhere, post and talk about days of the past. I started my "Long Island and NYC Places that Are No More" blog and Facebook page and found an audience waiting to share its experiences. What followed were people coming forth with all sorts of stories about their time spent at the amusement parks and submissions of hundreds of never-before-seen vintage photos.

In her last book, *Nunley's Amusement Park*, Marisa Berman tapped into the new Facebook audience and used it as both a tool to get old photos and to promote her work. Now she has written a new book on all the amusement parks in Brooklyn, Queens, Nassau and Suffolk Counties. I am endlessly grateful that she has chosen to cover such a wondrous and rich local history topic. Whether you spent time in these parks growing up or live on the island now and have wondered about their glorious past, this book is for you. As a testament to an era of great fun and enjoyment on the island, this work describes a vibrant and important part of Long Island's history.

Todd Berkun
Founder of "Long Island and NYC Places that Are No More"

ACKNOWLEDGEMENTS

I began this project after completing a history of the lost amusement park that I visited as a child growing up on Long Island: Nunley's Amusement Park. When I would speak at events about the book, so many people would mention other parks here that they cherished, and I quickly realized that there were many more stories that needed to be told. I am grateful for all of the people and organizations that helped guide me in researching this book and owe thanks to each person who submitted a photograph, story, memory or piece of memorabilia toward this project.

I would also like to thank Todd Berkun and his amazing "Long Island and NYC Places that Are No More" and his other blogs, websites and Facebook pages all dedicated to local history and Gary Monti, director of museum and theater operations at Cradle of Aviation Museum / Nunley's Carousel, for his advice on this project and past knowledge of the Nunley's run parks, as well as Dennis Ciccone Jr. and Steven Lercari.

Thank you to Gary Hammond, formerly of the Nassau County Department of Parks, Recreation and Museums; George Fischer and Iris Levin at the Long Island Photo Archive; Tara LaWare at the Society for Long Island Antiquities; Cynthia Krieg at the Freeport Historical Society; John Hyslop and Erik Huber at the Archives at Queens Library; Lisa Colangelo of the *New York Daily News* for her longtime support and her articles that have greatly aided me in obtaining photographs and stories; and Joe Behar for his memories of working at Gruberg's Amusement Park in Long Beach and the I Love Long Beach New York website. Thanks to Sandra Eaton and Noel

Acknowledgements

Eaton Chaney for sharing their memories of their mother/grandmother at Dodge City; Rhonda Gavsie and Marlene Platt Starr for sharing their experiences, photographs and other memorabilia from growing up at Garden Amusements (McGinnis's) with their father, Ted Platt; Madeline Lovallo for sharing her artwork and memories of the Crossbay Amusement Park; Bill Brent for his photos of the abandoned Adventurers Inn; Steve Pfeffer for his commitment to getting me photos of Buddy's; Nancy Radecker for her photos of Jolly Rogers and her past support of my first book project; and Karen Pavone of the "I Remember Fairyland Amusement Park" Facebook group. Amazing additional resources were the Long Island Studies Institute, the Long Island Memories Project, the Roller Coaster Database and the National Carousel Association.

Thank you so much to everyone at The History Press, particularly my commissioning editor, Whitney Landis. Your patience, expert guidance and constant check-ins helped make this book a reality. Also thank you to Jaime Muehl, my copyeditor, who went through this book with a meticulous eye.

I couldn't have made it through this project without the support and love of my family and friends. Thank you to the Berman family—particularly my parents, Ed and Carrie; my brother, Steven; and my nephews, Andrew and Gregory, who constantly remind me about the beauty and simple joys of childhood. I also want to thank the Price family, the Williams family and the Hollywood family. To my close friends Michelle, Tara, Stephanie, Eliane, Jacqueline, Colleen and Bonnie—your continued support of all my projects helps get me through the crazy times.

And finally, a special thank you to my future husband, Matt. I would have never been able to do this without your constant support, pep talks, technical assistance and love.

Introduction
AMUSEMENT PARKS ON LONG ISLAND

Long Island, New York, is 118 miles long and is currently home to almost eight million residents. Long Island is usually thought of as Nassau and Suffolk Counties, mostly suburban and, in some parts, farmland. However, Brooklyn and Queens, two of the five boroughs of New York City, are technically part of Long Island. This creates a unique land mass with an incredibly diverse mix of residents and environments. Regardless of where specifically they live, every single one of these Long Islanders has at some point needed the opportunity to unwind, and so the business of amusements has boomed here for over one hundred years.

After World War II ended, veterans moved from the city east to Long Island to raise their families. With this huge influx of people, businesses, restaurants and, of course, amusement parks began to develop to entertain the masses. Parks have thrived here over the years, specifically those geared toward the many children who call Long Island home. Kiddie parks like Buddy's Fairyland in Brooklyn, Adventurers Inn in Flushing, Nunley's Amusement Park in Baldwin and Dodge City in Patchogue have each played an important role in what it was like to grow up here. This book is a celebration of the amusement parks that Long Islanders have loved and unfortunately have lost. Through historic photographs, archival materials, ephemera and the memories of local residents, this book will tell the story of Long Island through the memories of its children.

Introduction

Amusement Parks in New York

Amusement parks are the heart and soul of America.
—Ralph Lopez, founder of the National Amusement Park
Historical Association[1]

The first amusement parks in America were mostly found along the East Coast in fields, groves and beaches near developing cities. These early parks were usually based around a single amusement—many times a carousel—and would later expand into full-fledged amusement centers with rides and games. New York has been a hub for amusements since the American amusement park industry first developed in Coney Island in the early 1800s.

As large cities like Manhattan were growing with new immigrant populations, people were eager to escape the congestion and heat of the city during the summers. The seaside areas of the outer boroughs—such as Coney Island in Brooklyn and Rockaway, Queens—were perfect spots for inexpensive outdoor amusements easily accessible by public transportation. These green areas served as picnic sites, but soon other amenities began

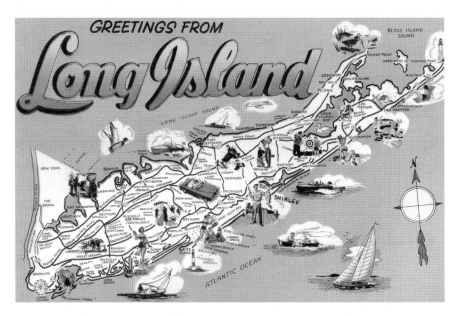

A postcard depicting the towns and sites of interest throughout Long Island. Note the emphasis on beaches, boating and the Ferris wheel representing Coney Island. *Author's collection.*

Introduction

to develop. In 1829, a new hotel, the Coney Island House, was built on Coney Island for visitors, and by the 1850s, pavilions boasting dancing, dining, bathing and even penny arcades had been constructed. In 1875, a railroad line was built, and visitation numbers skyrocketed. Numerous new businesses began to be developed by entrepreneurs looking to cash in on the crowds. The many visitors would relax with cold beverages and enjoy the fresh air untarnished by the crowded cities.

The Chicago World's Fair of 1893 also contributed to the rise of the amusement industry. This was when George Ferris introduced his Ferris wheel. It was also where Nikola Tesla demonstrated his techniques for alternating currents, among other demonstrations by those such as Thomas Edison, Western Electric and Westinghouse. The fair commemorated the 400th anniversary of Christopher Columbus's arrival in the New World. The impact of the fair can be found in many aspects of American art, design, literature and entertainment. Some of those influenced by the fair include: L. Frank Baum, author of *The Wizard of Oz*; architect Frank Lloyd Wright; and even Walt Disney, whose father, Elias, helped in the building of the so-called White City at the Chicago Fair.

The fair played a large role in the development of Coney Island's amusement area. Coney Island had three large amusement parks that lured the crowds to the beachside area: Steeplechase, which opened in 1897; Luna Park, which opened in 1903; and Dreamland, which opened in 1904. Although these names are still familiar to people around the country, all three parks are now lost—forced to close due to either fire or bankruptcy.

After the Stock Market Crash of 1929 and then the Great Depression, a large number of these lavish amusement parks began to go out of business. High numbers of visitors still frequented the parks, but they weren't spending money. Fires and bankruptcy led to the end of the golden age of Coney Island. Although the Depression was painful, it was the establishment of Robert Moses as parks commissioner in 1934 that really caused problems for the area. Moses wanted to replace the amusement area with more beaches, recreation areas and parking lots. His development of Orchard Beach in the Bronx and of Jones Beach in Nassau were part of his plan to draw visitors away from Coney Island and Rockaway Beach.

When Moses established Jones Beach State Park in 1929, he made it clear how he intended the park to be run. In a *New York Times* article printed on August 4, 1929, he is quoted as saying, "We want to get away from the

Introduction

idea of the amusement park…We want to give the people of New York and suburbs a place where they can spend a day quietly at the beach." But even the article's author seems to mourn this change in tone toward amusement parks. He writes, "The beach has ten miles of level ocean front, and as it is ideally suited for surf bathing, it will be used for that alone…[and] there will be no side-shows, no carrousels and no hotels; only a restaurant and a refreshment stand."[2]

Another factor in the decline of the amusement park boom was the constant destruction caused to the parks by its unruly visitors:

> *Though amusement parks have always had to cope with sailors on leave, college kids full of beer, high school punks, and other rowdies, today's bewildered, unemployed hoodlum is likely to vandalize anything to compensate for his sense of inferiority. Vandalism has doomed more amusement parks than any other single factor.*[3]

Aside from vandalism, developers looking to take over prime real estate have also led to the demise of many parks built in or near large cities.

The Kiddie Park

At the turn of the century, many of the beach resorts that were nearby or part of the large amusement parks had a few so-called kiddie rides within their gates, but the amusements were generally focused on adults. The Hershey Company was a forerunner in the children's amusement market. In 1915, Hershey Park in Hershey, Pennsylvania, sectioned off an area of the park with some playground-type amusements like slides and swings. By the 1920s, Hershey's kiddie area had a boat ride and a mini Ferris wheel. Kennywood Park, located in a suburb of Pittsburg, Pennsylvania, also created a kiddieland within its park. This was a larger more elaborate children's area. The owners created mini versions of the sixteen most popular rides at the park. The first amusement park that was entirely dedicated to children was developed by C.C. Macdonald, who opened Kiddie Park in San Antonio, Texas, in 1925.

After the explosion of the amusement park industry at the turn of the century and its subsequent demise with the Great Depression, we didn't see a rise in the development of amusement parks again until after the end of

Introduction

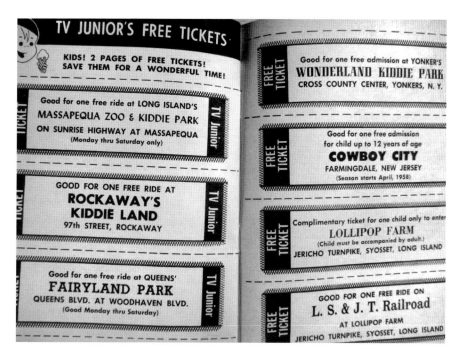

Ticket vouchers for kiddie parks in the tri-state area found in the April 1958 issue of *TV Junior*. *Courtesy of Joseph Kuceluk.*

World War II. In the decade that followed, Nassau County saw a doubling of its population numbers to more than one million residents:

> *With the mushroom growth in population of suburban Long Island following World War II, including a significant number of small children, kiddie parks in the area have also grown into big business. Operators report that takes are good and new parks are springing up rapidly.*[4]

It was at that time that veterans returning home decided to leave the confines of the crowded cities. Many moved to the suburbs to start families, and a new type of park began to develop to capitalize on this change: the kiddieland. *Billboard* magazine published a story in 1949 entitled "Kiddielands Are Here to Stay" claiming that the age-specific parks were "depression proof" even though they cost from $40,000 to $100,000 to open. The author was confident that a poor economy wouldn't affect sales because "no matter how bad conditions may be, sonny will pay his regular visit to the neighborhood Kiddieland with mom and dad. Sonny's pleasures and

Introduction

self-development will come before many other items on the family budget."[5] He also stated that the kiddieland was "a vital unit of juvenile development, comparable in value to the school and Sunday school."[6]

In 1956, the Allan Herschell Company published a guide for running kiddie parks. *Kiddielands: A Business with a Future* provided information on choosing a location, rides, designing the park's layout, ride maintenance and understanding insurance and legal issues. Herschell claimed that at least one hundred new kiddielands would need to be opened to match the population growth. That same year, *Billboard* magazine reported that there were fifty-five kiddie parks in the New York area alone. There was a great deal of competition among all of these local parks, and some hostility was clearly apparent when yet another new park would open. In an advertisement from June 1958, Jolly Rogers—the restaurant adjacent to Nunley's Happyland in Bethpage—ran a deal that read: "As a salute to the latest Adventurers Inn Flushing, NY, Jolly Rogers offers 1 pint famous Louis Sherry French Ice Cream regularly .60 only 25 Cents."[7]

Malls, shopping centers and parks also tried to capitalize on this new audience by adding small rides and carousels. These types of kiddie areas were exclusively designed for young audiences and were created with the idea that parents would feel comfortable leaving their children at the ride area while they shopped. Drive-ins soon became popular locations for kiddieland tie-ins and in many cases helped to further boost business. Some parks even offered two-ride tickets per child with their movie tickets, which quickly led to additional purchases by parents. Many theaters began bringing special guests like clowns or other costumed characters to encourage families to come to their businesses.

In the late 1940s to early '50s, large theme parks began to develop across the country. These parks boasted huge expanses of property, titillating rides and various amenities, blowing away the offerings of the tiny but numerous kiddie parks. While many of these small parks were forced to close, some were able to continue operating. The kiddie parks were less expensive, close to home and had stronger ties to their immediate communities.

The question now to be determined by park owners was whether they should continue with just kiddie rides or add rides geared for teenagers and adults as well. The problem was that adding major rides could potentially create a decline in business. While it would bring a new, older cliental, it might scare away parents from bringing their small children if there were large and adventurous rides that seemed dangerous. Also, establishments with major rides tended to attract teenagers in large groups who would

Introduction

dominate the park, moving away from the family-friendly atmosphere to which parents with small children would be attracted. Ride manufacturers like Fred Mangels of William F. Mangels Company felt that not having both types of rides was a potentially missed opportunity: "If the family comes upon the large Carousel, the parent must ride it with the kiddie. With a miniature device alongside, the parent is prone to place the child on it, and the park owner has therefore missed a chance to have the adult take a ride."[8]

Safety was a huge priority in kiddie park operations, and insurance premiums were high. For the kiddie parks that were in Brooklyn and Queens and officially part of the five boroughs of New York City, there were additional challenges: significantly more operation restrictions. For example, in New York City parks, not only did all ride operators have to be over the age of twenty-one, but they also had to have a license for the individual rides they were operating. City inspectors were also constantly visiting parks to check for violations of safety, fire and electricity.

When the baby boom came to an end in the mid-1960s, the kiddie park trend around the country began to die out as well. Many of these parks either closed or were modified to attract an aging clientele by adding arcades, miniature golf courses and batting cages.

Remembering Our Park

Each of us has *our* park—the one that we visited as children that will never compare to any other. For Al Griffin, amusement park historian and author of *Step Right Up, Folks!* (1974), nothing would compare to the Riverview Park in Chicago:

> *Cheap, tawdry, not-quite-honest, it was still that most fascinating of all entertainment—the traditional amusement park. Since then I have frequented amusement parks all over the country, but in my eyes none ever matched Riverview. Maybe because it is gone now, everything looks better in retrospect.*[9]

Many parks were family owned for generations, and it wasn't an easy business by any means. Rhonda Gavsie, whose father, Ted Platt, ran Garden Amusements, better known as McGinnis's, in Garden City Park for over thirty years, remembers how challenging it was to run a kiddie park even

Introduction

during their heyday: "During the season, he worked very long days, seven days a week. In the winter, he was home most of the time and did not have income. He had to learn how to budget his income from the spring/summer to last all year." Weather became a huge factor in income for owners, as well. Rhonda continued, "Rain was considered a dirty word in our house because if it rained, it meant lost income that could never be recovered." This was an issue faced by many of the parks across Long Island. For the parks that were located near seaside areas, owners would actually hope for cool and cloudy days, rather than warm and sunny, so they wouldn't lose customers to the beach.

This book was incredibly challenging to produce. I stumbled upon more parks than I could have ever imagined existing on Long Island. Unfortunately, many of these parks had little or no information to be found on them aside from a name or location. I have attempted to provide details on as many parks as possible, but I could not cover all of them. I apologize in advance if a park you loved is not featured here or if an important feature as a visitor to that lost park was not mentioned. In my research to learn the unique details of the lost parks, I visited archives, historical societies and museums; interviewed past park owners and their descendants; spoke to past and present residents who visited the parks; and looked through multiple newspaper databases. I also pored through thousands of posts on social media, blogs and websites, and it was here that I was able to observe the impact that these parks had on their visitors. All the comments had the same tone: nostalgia for lost childhoods. Memories were reborn just from a glance at an old image or a dialogue that began with "Do you remember…?" The comment that I most consistently found was: "I wish it was still there so I could bring my kids." Unfortunately, almost all of these parks are gone, and there is no changing that. However, I hope that this book will remind you of these once thriving places and bring you back to a seemingly simpler time—a time when there was nothing better than your parents bringing you to your park so you could play and just enjoy being a kid.

Chapter 1
BROOKLYN PARKS

Coney Island, home to the amusement park industry, had some of the world's most famous amusement parks—like Dreamland, Luna Park and Steeplechase. These parks, and the others that developed here, were meant to attract and entertain an older audience. By 1930, however, some of these parks had established kiddie areas within their parks that had miniature versions of their main rides segregated into corners so children wouldn't be hurt by the larger, more dangerous rides. Many kiddie parks have operated over time in Brooklyn, but few managed to survive.

Fairyland Kiddie Park (Buddy's Fairyland)

Utica Avenue, Canarsie • 1952–2002 • LOST

In April 1952, Irving Miller, an ironworker looking to change careers, and Leo Davis, an independent operator of kiddie rides, joined together to open their own kiddie park. Fairyland was located in the Canarsie area of Brooklyn on Utica Avenue, off Flatbush Avenue. Upon first opening, the park was 100 by 200 feet with a thirty-car parking lot. The park had four rides, all by King Amusement Company: a rocket, autos, a wet boat and a train. A year later, the park had expanded to 100 by 350 feet, and its parking lot could now hold one hundred cars. It also added a three-abreast Herschell carousel, a junior

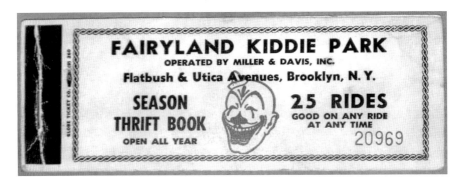

A ticket book from Fairyland Kiddie Park, more commonly known as "Buddy's," in Canarsie, Brooklyn. *Courtesy of Marc Solomon.*

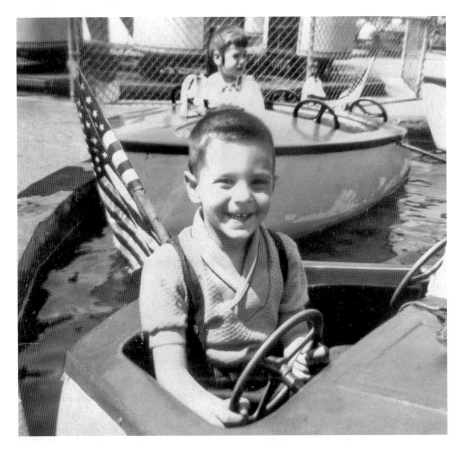

The wet boat rides at Buddy's. Note how each rider gets his or her own steering wheel. *Courtesy of Steve Pfeffer.*

roller coaster, a Ferris wheel and a Whip. In 1953, the owners also opened a new building containing a penny arcade and a restaurant.

While some of the park's visitors were nearby residents, the majority of business came from motorists who passed the park at its highly visible location on Utica Avenue. Rides were nine cents each or three for twenty-five cents. Books for thirty rides cost two dollars. Adults could ride the carousel and roller coaster for fourteen cents each. Miller and Davis used automatic timers on their rides, capping the journey at two minutes and making things easier and more efficient for operators.

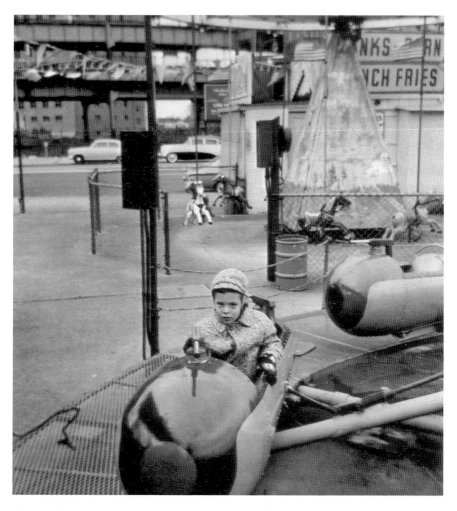

The Sky Fighter ride was extremely popular and could be found in kiddie parks around the country. *Courtesy of Steve Pfeffer.*

Historic Amusement Parks of Long Island

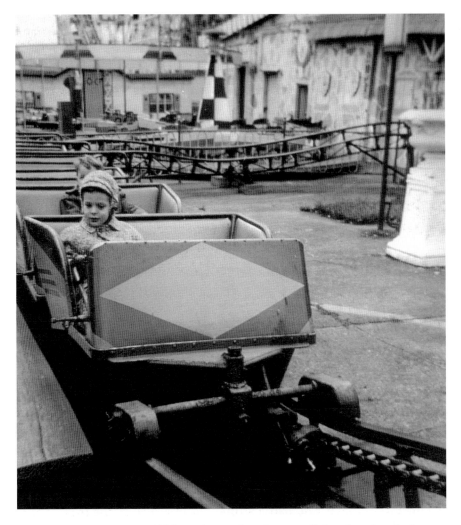

The roller coasters at many kiddie parks may have been small, but they played a large role in creating (or preventing) future thrill-seekers on big theme park coasters. *Courtesy of Steve Pfeffer.*

As all kiddie park owners could attest, the hours were long—the park even remained open on weekends during the winter—and the operations brought many challenges with New York City regulations and inspections. Amid these difficulties, business was good. The owners rarely advertised or had giveaways, and even after two years of operation, they kept their ticket prices the same even though surrounding parks were starting to increase prices.

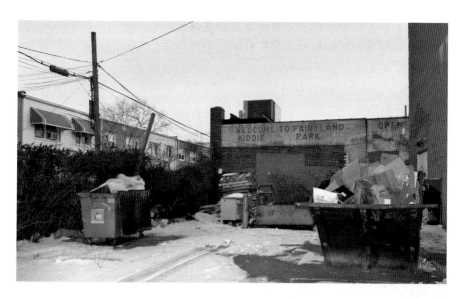

All that remains of Fairyland Brooklyn today. *Author's collection.*

The restaurant next to the park was called Buddy's Food and Fun and served fish and chips, hamburgers, roast beef sandwiches and other boardwalk-type favorites. Due to the popularity of the restaurant, many visitors and residents commonly referred to the kiddie park as Buddy's right up until its closure. The kiddie park was completely enclosed and had brightly colored painted cutouts of wooden soldiers, clowns, spaceships and other characters along the perimeter of its fence. The kiddie rides did change over the years. Visitors may recall a helicopter ride where riders could actually control moving up and down with a lever or how the wet boat ride had a string tied to a bell on the front that a rider could ring.

When Irving Miller retired, his son Steward ran the park. The park was still thriving in the 1980s and '90s and served as a place of employment for many local teenagers. During this time, the arcade became even more popular. It had pinball, Space Invaders, Pong, Tetris, Double Dragon, a photo booth, a coin-operated fortuneteller, a penny press and a recording booth where one could record 45s.

Fairyland closed in 2002. Today, the site that was Fairyland is a Petco.

Historic Amusement Parks of Long Island

McCullough's Kiddie Parks

Surf Avenue, Coney Island • ca. 1948–2012 • LOST

Located at Surf Avenue and Twelfth Street at the Bowery in Coney Island, this park was owned by the McCullough family, who had deep roots in the amusement park industry. The McCulloughs were related to the Tilyou family, who owned Steeplechase Park, as well as the Stubbman family, who ran a carousel in Coney Island that today operates in Flushing Meadows–Corona Park. Four generations of the family worked in the industry operating parks and rides, as well as being traveling showmen.

In 1944, brothers Leonard and George McCullough first opened a park on Surf Avenue and West Eighth Street across from Steeplechase. There they operated a sixty-eight-passenger carousel, which they had moved from a site in Long Beach called Jackson's Park. At that time, the property still adjoined the cottage "Eileen Villa," where their mother, Kathryn Tilyou, was born and where their father, James McCullough, operated Coney Island's first shooting gallery. In 1948, the brothers razed the house that had been in that location for over a century and expanded their kiddie park over the area. Also about 1948, another brother, James McCullough Jr., began operating the carousel. Soon, it officially became McCullough's Kiddieland with fifteen rides, and now four McCullough brothers (Leonard, George, James Jr. and Theodore) were involved in the business.

In 1948, George was elected president of the Coney Island Chamber of Commerce. He worked on numerous projects to boost attendance numbers for the area's amusements. He appealed to Robert Moses to sell some of the parcels of land the city had recently taken over in the area to private owners with the idea that these potential transactions could bring revenue to the city from taxes and licensing. George's hope was that the amusement area would expand into these locations that were currently outside of the resort area.

The brothers also owned another kiddie park at Surf Avenue and West Fifteenth Street. This second park had seven rides, including a miniature train, a wet boat, a fire engine, a jeep ride, a jet plane, Little Skipper and auto racers, as well as a carousel and an arcade. In addition to the kiddie parks, the family ran multiple carousels, including one on the boardwalk in front of Steeplechase Park and one in Prospect Park. They maintained two large parking lots, one at West Fifteenth Street for one hundred cars and one at West Eighth Street for three hundred cars. There were also multiple concessions and the Atlantic Bar and Grill.

In 1961, James (Jimmy) McCullough III, James Jr.'s son, opened the last McCullough kiddie park on two adjoining lots at West Twelfth Street. The park's rides were a carousel, a miniature train, a Ferris wheel, Ladybug, Frog Hopper, a boat ride, Yellow Submarine, motorcycles, Bumblebees, Himalaya, Dizzy Dragons and Swings. Jimmy McCullough had helped his father and grandfather in the family's amusement business and dedicated his own career to Coney Island. He even met his future wife, Lois, at the Stubbman Carousel on the Coney Island boardwalk in the 1950s.

In 2011, McCullough's started getting pressure from property owners Thor Equities and didn't renew its sublease on a section of land in its park. This forced it to remove two of its twelve rides: a miniature train and a boat ride. Hurricane Sandy in October 2012 badly damaged the park, and this was the beginning of the end.

The park ultimately closed on December 31, 2012, when the McCullough family wasn't able to come to an agreement regarding their lease with Thor Equities. At that time, two of Jimmy's four daughters, Carol and Nancy, fourth-generation McCulloughs in the amusement business, were running the park. Their father, Jimmy, was the oldest ride owner in Coney Island at the time of the park's closure. It was the first time since 1862 that a Tilyou descendant wasn't operating a park in Coney Island. Jimmy passed away in August 2013. The Eighth Street kiddie park is now the New York Aquarium, and the Fifteenth Street kiddie park is now the parking lot of Gargiulo's Restaurant.

Nellie Bly Amusement Park / Adventurers Family Entertainment Center

Shore Parkway, Bensonhurst • 1951–Present • www.adventurerspark.com

In 1951, brothers Alfred and Henry Romano opened a concession stand at a new kiddie park, with a third brother, Eugene (Gene), becoming an investor in their operations. The park was named Nellie Bly Kiddieland after the adventurer and investigative reporter Nellie Bly, born Elizabeth Cochrane, who lived from 1867 to 1922. Bly is best known for her successful trip around the world, completed in seventy-two days—beating the fictional character of Phileas Fogg in Jules Verne's *Around the World in Eighty Days*. Her journey was highly publicized and made her a celebrity. The park was named after Bly because of her adventurous

HISTORIC AMUSEMENT PARKS OF LONG ISLAND

A sheet of ride tickets from Nellie Bly Amusement Park. *Author's collection.*

spirit. Over the next fifteen years, the family successfully ran the concessions until the land the park was on was sold for development and the park closed. The Romano brothers purchased four of the park's rides at auction and found a location for a kiddie park of their own down the street from the original site.

The family leased their three-acre property from the New York City Parks Department, which took ownership of the land in 1956, along with the Southwest Brooklyn Sanitation Center. Located on the bay side of the Belt Parkway, the park officially opened in the spring of 1967. The new Nellie Bly's had five rides, four from the original park—a carousel, wet boats, a fire engine and a kiddie roller coaster, plus a new helicopter ride. The community became

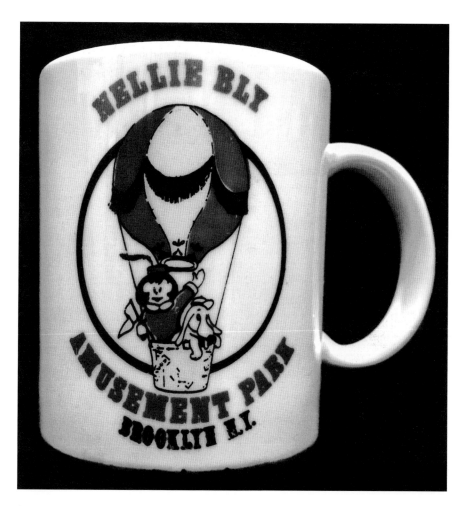

A souvenir mug from Nellie Bly's. *Author's collection.*

fast supporters of the new park, and the brothers added additional rides: a Ferris wheel, a miniature train, Tilt-a-Whirl and a large slide. A few years later, in 1969, the park also began operating a defunct driving range located next door; this lasted for only a few years. In the mid-1970s, bumper cars were also added.

The park went through improvements during the late '70s when new concessions were added, along with additional rides and a miniature golf course. A big change came in 1982, when the family was able to secure a ten-year property lease from the city that allowed them to make more permanent modifications to the park. A forty-three-foot roller coaster, called The Flash, was added, along with a Nellie Bly–themed funhouse and a go-cart track.

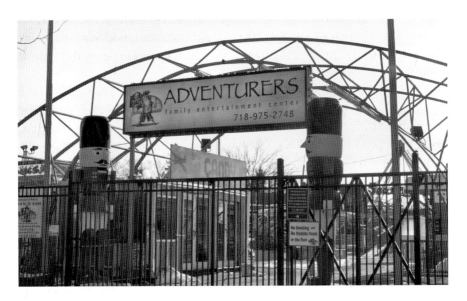

The entrance gate to Adventurers Family Entertainment Center today, as seen from Shore Parkway, flanked by wooden soldiers. *Author's collection.*

Motorcycles and other kiddie rides at Adventurers Inn today. *Author's collection.*

In 1986, Gene Romano bought out his brothers and took full ownership of the park. He made over $200,000 in additions and modifications in the following years. In the '90s, the park was incredibly successful, with frequent updates and high attendance numbers.

When Eugene Romano passed away in 1999, his wife, Antoinette, and daughter, Gena, took over the park. Gena would go on to become the International Association of Amusement Parks and Attractions' (IAAPA) first female president. In 2004, Gena reported that the now twenty-two-ride park had approximately 150,000 visitors come to the park a year and held around eight hundred birthday parties.

At that time, the park also had a petting zoo with rabbits, chickens, goats, llamas and other farm animals, as well as a batting cage. Gena made multiple ride additions and changes, including replacing the roller coaster with a family swing ride.

In 2005, the Romanos sold the park. In 2007, the park was taken over by new owners; it was renovated and renamed Adventurers Family Entertainment Center.

Today a twenty-five-ride park, the rides include Cyclone Racer, a miniature train still referred to as the Nellie Bly Express, a roller coaster, a carousel, Flying Fairy Tales ride, a plane ride, a motorcycle ride, a water slide, Sea Dragon, Himalaya, Pink Elephants, Fun Slide, Bear Affair, Tilt-a-Whirl, Frog Hopper, helicopters, cars and a classic wet boat ride. There are also bumper cars, a miniature golf course, a new go-cart course, carnival games and concession stands.

This kiddie park can clearly be seen from the Belt Parkway today and is one of only a few kiddie parks from the baby boom that is still in operation in some capacity. Although the name has changed and the park has evolved, many visitors still (and will always) refer to the park as Nellie Bly's.

Peter Pan Playland

2609 Emmons Avenue, Sheepshead Bay • 1954–1970s(?)

In 1948, the owners leased a block of vacant land on Emmons Avenue in the area of Brooklyn known as Sheepshead Bay. By June 1954, kiddie amusement rides and concessions had been installed, and Peter Pan Playland opened to the public. The park had various rides, including Little Dipper, a carousel,

cars, a wet boat ride and a Ferris wheel. The park is best remembered for its miniature train ride that went around the perimeter. Employees of the park would have to slide closed the main entrance gate when the train was passing to prevent visitors from crossing the tracks. Visitors may also recall performances by "Johnny Jellybean," aka Bill Britten, an actor who became famous for playing Bozo the Clown.

Next to the park was a frozen custard stand, and there was a miniature golf course, called Sheepshead Bay Golf Course, at East Twenty-seventh Street and Emmons Avenue. The area had many amusements and restaurants like the famed Randozzo's Clam Bar, which is on Emmons and Twenty-first Street.

The owners of the park were involved in a grievance with the City of New York in 1961, when they petitioned to install a parking lot of part of the property they had originally leased in 1948 but were met with opposition because that area of the property was zoned for only residential use.

Sometime around 1971, Peter Pan Playland closed and changed locations, moving to 2461 Knapp Street. The park reopened here along with a restaurant and an arcade until some point in the '70s. In 2005, the new site of Peter Pan Playland was rezoned to become a Public Storage franchise.

Ward's Kiddie Park / Deno's Wonder Wheel Park

Boardwalk and West Twelfth Street, Coney Island • ca. 1940s—Present • www.wonderwheel.com

Coney Island's famous Wonder Wheel opened to the public on May 30, 1920, and was built by Charles Herman of the Eccentric Ferris Wheel Company. Until the Parachute Jump was moved to Coney Island in 1941 from Flushing Meadows–Corona Park, where it was built for the 1939 New York World's Fair, the Wonder Wheel was the tallest ride in the area at 150 feet. The ride is an elaborate Ferris wheel with twenty-four gondola cars, sixteen of which move within an inside track, and eight stationary cars around the perimeter. It can hold a total of 160 passengers. Herman Garms operated the Wonder Wheel, and in 1955, he also added the Spook-a-Rama ride.

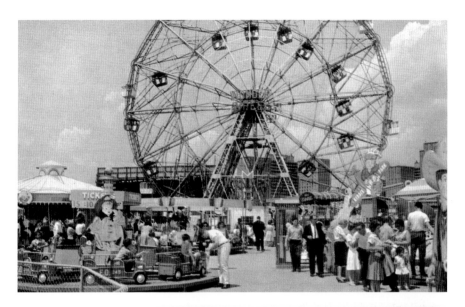

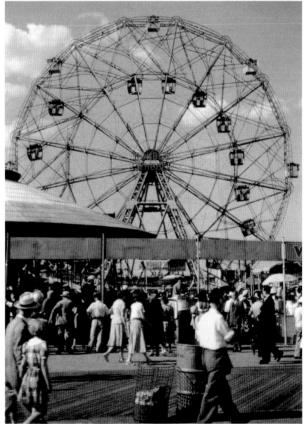

Above: A postcard showing some of the kiddie rides at Ward's Kiddie Park, Coney Island. Ward's operates today as Deno's Wonder Wheel Park. *Author's collection.*

Right: A postcard of the Wonder Wheel, photographed from the boardwalk in 1950. The "W" visible on the sign at the right reads, "Ward's Kiddie Park." Author's collection.

HISTORIC AMUSEMENT PARKS OF LONG ISLAND

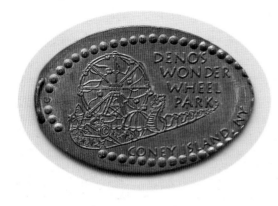

A machine-pressed souvenir penny from Deno's. These elongated coins first became popular in America after their introduction at the 1893 Chicago World's Fair. *Author's collection.*

In the 1950s, the Wonder Wheel sat behind Johnny Ward's kiddie park, which was on the boardwalk. Ward's was leased to John Curran. The kiddie park had many rides, including a Sky Fighter, Roto-Ship, a fire engine, a pony cart, a motorboat, Dragon, a handcar, a kiddie Ferris wheel, a jeep and Rock-o-Plane. The park also had a large whip, a carousel and a roller coaster. Ward's was managed by Robert Buckley, and its head performance man was Michael Curran, John's brother.

The Wonder Wheel has long served as a symbol of Coney Island, so Ward's Kiddie Park, being in such proximity to the iconic structure, became an important venue. Various events were held at the park. In 1970, it was the venue for the "Most Glamorous Grandmother Contest," where forty-three-year-old Mrs. Marion DeFeo was crowned winner with her dimensions of 34-24-36.

Deno Vourderis, the eighth of twenty-two children, immigrated to New York from Greece in 1934 and joined the Merchant Marines at the age of fourteen. When he was discharged in 1946, he registered for a peddler's license and began working at food pushcarts. Deno worked in food service through the 1960s, at which time he purchased the Anchor Bar and Grill on the Coney Island boardwalk next to the Cyclone. He expanded his business a few years later when he opened a food concession at Ward's Kiddie Park in 1970. A famous story is that Deno always wanted to own the Wonder Wheel and that he proposed to his wife on the ride, proclaiming that if she said yes, he would one day buy her the wheel—giving her the biggest ring in the world. Working at the park was his entry into the amusement park business.

By 1976, Deno was helping owner John Curran run the park. In 1981, Deno ended up purchasing Ward's Kiddie Park from a retiring Curran.

Brooklyn Parks

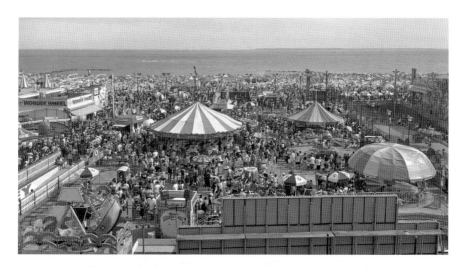

An aerial view of Deno's Wonder Wheel Park today. *Photo by MusikAnimal.*

It was a time when Coney Island was beginning to struggle economically, but Deno and his family worked hard to keep the amusement park successful. And then he finally made good on his promise to his wife, thirty-five years late: he purchased the Wonder Wheel. He bought the wheel, as well as the Spook-o-Rama ride, in 1983 from Herman Garms's son Fred for $250,000, with another $250,000 for repairs. The hard work and large expense paid off; the Wonder Wheel became a New York City Landmark in 1989.

The family purchased a vacant building next door to their park that had been damaged in a fire. With this additional property, they added three new rides. A new park was officially created: Deno's Wonder Wheel Park.

Deno was very active in the Coney Island and amusement communities; he even served as president of the Coney Island Chamber of Commerce. Deno passed away in 1994, and his sons Dennis and Steve took over the park, which is still in operation. Today, there are seventeen kiddie rides, including Big Trucks, boats, a carousel, a teacup-type ride called Dizzy Dragons, fire engines, Flying Elephants, a twenty-five-foot-drop Free Fall, jets, Jumping Motorcycles, Mini Pirate Ships, Pirate's Pond, Pony Carts, Rio Grande Train, Samba, Tilt-a-Whirl, Willie the Whale and the custom-designed Sea Serpent Roller Coaster. Visitors of any age still ride the Spook-a-Rama and, of course, the beloved Wonder Wheel.

Historic Amusement Parks of Long Island

Wonderland / Astroland Kiddie Park

Surf Avenue, Coney Island • 1955–2008 • LOST • Luna Park • lunaparknyc.com

The two square blocks of property on Surf Avenue reaching the boardwalk originally operated as Feltman's Park and Restaurant from 1871 until 1946. Charles Feltman, the owner, is credited as the inventor of the hot dog. Nathan Handwerker, the founder of Nathan's Famous, who literally made the hot dog famous, worked at Feltman's until he left to open his own business. Charles Jr. and Alfred Feltman ran the business after their father's death in 1910. The Feltman's restaurant was an icon in Coney Island. Feltman's surrounding park area also had many kiddie attractions, including rides, a carousel, a petting zoo, a miniature golf course and a penny arcade. The brothers retired around 1947 and sold the property. The property was purchased by Benno Bechhold, Alvin Coleman (sometimes listed as Kallman) and Harry Socoloff, who undertook major renovations of the property. It was the last of Coney Island's big dining spots still in operation since the area's heyday of amusements.

The kiddie park at Feltman's Restaurant, Coney Island. The park would later be known as Wonderland and then would evolve into the Space Age–themed kiddie park Astroland in 1962. *Courtesy of Brian Merlis/Brooklynpix.*

Brooklyn Parks

Wonderland Park opened in 1955 and was behind the old Feltman's restaurant and carousel building. At first, the carousel remained in operation, as did the Faber Arcade, but the restaurant was to be refurbished, and a new restaurant was to take over the space. The property was owned by Coney Island Enterprises Inc., which was made up of Herman Rapps, Dewey Alberts, Sidney Robbins, Paul Yampo and Nathan Handwerker (as a silent partner). The new park operated as a cooperative where concessionaires operated independently. The corporation purchased the park at auction in 1954 for half a million dollars.

The Garto brothers—Frank, Anthony, Joseph and Alfred—ran the majority of the park. The brothers had previously run the kiddieland at Feltman's, including a roller coaster, Little Dipper, Sky Fighter, wet boats, a helicopter, an Eli Ferris wheel, an auto racer, Jolly Jeeps, a fire engine and a pony ride. Now, the brothers expanded their operation with additional kiddie rides and adult rides as well. When Wonderland opened in 1955, the rides now included a hot rod, Whip, a National train, Tilt-a-Whirl, Looper, a shooting gallery and game stalls. The park now had fifteen kiddie rides, ten major rides and twenty-five games. The Garto brothers had also run another kiddie amusement area on Stillwell between the Bowery and the Boardwalk in the late '40s.

There was a strong advertising campaign for the park's opening, promoting free performances by a high-wire act. Unfortunately, a week before the opening, the entertainer had an accident performing at White City Park in Worcester, Massachusetts. Since the performer couldn't appear, the program had to be dropped. In their second season of operation, the Coney Island area was hit with bad weather, which kept visitors away.

By 1961, Nathan Handwerker had sold his share to Dewey Alberts. Handwerker had originally considered relocating his Nathan's Famous to the Feltman's property, which was why he became involved in the purchase of the property, but he later changed his mind. Alberts and his son Jerry began a massive renovation of the park, opening the space age–themed Astroland in 1962. Popular features of the park were the 1960s-era spaceship that operated as a ride until the mid-'70s and then was on display welcoming the crowds into the park. The 71-foot-long, twelve-thousand-pound ship could hold twenty-six riders. There was also the Astrotower, a 272-foot-tall structure with a glass car that rotated 360 degrees and provided unobstructed views of the ocean and New York City. The family made the park a popular site in Coney Island, helping to boost what was a business slump in the area during the '70s. They also took over operations of the Cyclone roller coaster

from the city after it had fallen into disrepair. They restored the coaster and reopened it in 1975. Gerry took over the park operations after his father died in 1992. Unfortunately, Jerry became ill soon after, and his wife, Carol Hill Alberts, took over management of the park.

In 2003, Mayor Bloomberg implemented a rezoning project for Coney Island. The Astroland property, the largest privately owned area in Coney Island, became an extremely valuable commodity. Although Carol wanted to maintain the park and move forward with her own plans for renovations and updates, the future of the park was unclear. She ultimately sold the property to Thor Equities, which purchased the land for $30 million in 2006. Astroland closed on September 7, 2008.

In 2005, a revitalization plan was established by the Coney Island Development Corporation, which encouraged the growth of the amusement area. A new amusement park, the New Luna Park, opened on the site of Astroland in May 2010. This park has over nineteen rides and attractions, including a kiddie ride section. The Cyclone was declared a New York City Landmark in 1988 and was still operated by Carol Alberts until 2011, when it was taken over by Luna Park. The city tore down the Astrotower in 2013 due to its instability. The Astroland Rocket, after being in storage for five years, was acquired by the Coney Island History Project. It had the rocket restored in partnership with the Vouderis family of Deno's Wonder Wheel Amusement Park, and in 2014 it was moved into that park.

Worth Mentioning

These are parks that I came across in my research but couldn't find much information on—do you remember?

Brighton Kiddie Park

Boardwalk and Brighton First Road

Dreamland Kiddie Park

Hillside Avenue, Brooklyn • Opened June 1953

Owners: Frank Sadowski, Albert Seyman
Five rides

KIDDIE WONDERLAND

Kings Highway and Forty-eight Street, Brooklyn • 1954

Owner: Max Gruberg
Twelve rides: Philadelphia Toboggan, Big Eli Wheel, Caterpillar, a roller coaster, Whirl-a-Round, a kiddie Ferris wheel, a train, a rocket fighter, a jet aeroplane, Chair-o-Plane, a tank and a water boat

UTICA FUNLAND

ca. 1952

Manager: Larry Stein
Purchasing Agent: Edward Schwartz
One major ride, five kiddie rides, two refreshment stands and free parking

Chapter 2
QUEENS PARKS

The largest of New York City's five boroughs, Queens has long lived in the shadow of Brooklyn in terms of being a seaside resort area. However, the Rockaways has been home to numerous beaches, bungalows, restaurants and, of course, amusement parks, including Rockaways' Playland. There were amusement parks to be found across the borough, particularly during the 1950s and '60s. Unfortunately, none of these parks has survived.

Adventurers Inn / Great Adventure Amusement Park

Whitestone Parkway, Flushing • 1957–1978 • LOST

The Adventurers Inn was originally a restaurant in Yonkers that was operated by Max Lander. This eatery was next door to a kiddie park run by Miriam Nunley, who ran parks throughout Long Island. The park and restaurant opened in 1945 and were located on Central Avenue with a carousel and three kiddie rides. Both were forced to close due to the construction of the New York Thruway. But this was not the end for Adventurers Inn.

Fun Fair Park officially opened in 1957 and was unique in that it was the first amusement park in an area where numerous parks were located that ran on percentage operations—meaning that all the rides and concessions were

HISTORIC AMUSEMENT PARKS OF LONG ISLAND

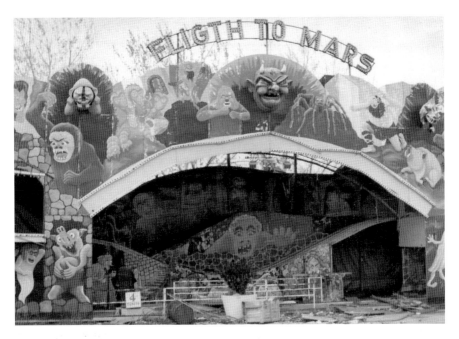

Visitors to Adventurers Inn in Queens will recall that the Flight to Mars funhouse ride had a typo on its sign. *Courtesy of photographer Bill Brent, www.bbrent.com.*

contracted out. The contractors had to yield a percentage of ticket sales, participate in promotions and abide by the rules stated by Fun Fair. Fun Fair, in turn, provided the site, electricity, promotion and central ticket operations for all contractors.

The park was located at Linden Street and Whitestone Parkway—only minutes away from the Whitestone Bridge and near LaGuardia Airport. The business was given a twenty-five-year lease on the property. The park was based on the design of a preexisting restaurant building. Work on this building held up the opening, originally planned for July 1956, so rides were open almost two years before the restaurant. Max Lander, operating the new restaurant, was one of the park's largest tenants. The lavish new eatery would hold the name the Adventurers Inn. The building also housed a carousel from Hot Rods Inc., an arcade and a kid's party room. The building also had a twenty-five-foot-tall sign with illuminated letters, making the park visible from the bridge. It was due to the restaurant's sign that the park quickly became known as Adventurers Inn.

To help promote the park's opening, Fun Fair partnered with a network television show to be a telecast site for a Dean Martin telethon raising funds

for treating leukemia through the Blood Disease Center at the City of Hope in California. The park welcomed popular characters and stars of television, film and sports to help raise donations. They included Jackie Robinson, Hank Bauer, Marty Glickman, Sandy Becker, Superman, Wyatt Earp and Captain Video. Unfortunately, the weather was terrible, but the television exposure still helped publicize the new park. Fun Fair advertised in the *New York Post*, the *Long Island Star-Journal* and the *Long Island Press* with coupons for rides and the restaurant.

Kiddie rides were ten for one dollar, while the major rides were six for one dollar or twenty-five cents each. The park was designed to have a rustic appearance, with log railings and sprawling landscaped lawns for its twenty-one rides. It was made up of four acres of rides and six acres of parking—parking for one thousand cars. The construction was completed by Boro Realty Company.

For its percentage operation, rides were contracted out for ten-year leases. An article in *Billboard* in November 1953 listed the contractors and their rides, including Harold Fredericks, former Indian Point Park tenant: Big Eli Wheel, kiddie fire engine; Lejak Amusements (Fred Jacobs and Lou Schwartz) of Coney Island: Hot Rod, German Skooter; Joe Alberti and son:

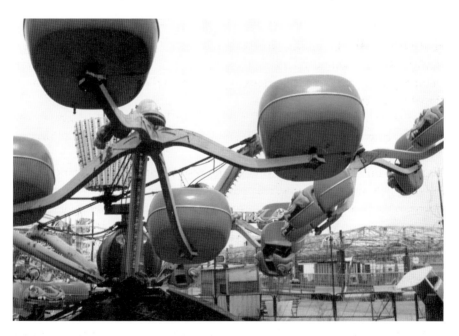

Brightly colored rides from the park's shift from kiddie rides to a large-scale amusement park. *Courtesy of photographer Bill Brent. www.bbrent.com.*

Historic Amusement Parks of Long Island

National's Century Flyer train, eighteen-hole miniature golf; Louis Damelio: Junior Hot Rod; Ralph Stabile: Herschell kiddie tanks, National pony carts; Sorci & Company: Teetercopter; Carl Bennett: Tilt-a-Whirl; Rose Scriloff: National's Comet Junior Coaster; Ed Steinberg: Herschell Sky Fighter and boat ride; Morris Schmier: Mangels Junior Whip, National's Pony Trot; Sam Kersch: kid rocket, Ferris wheel, Herschell Jolly Caterpillar; and Sal and Ralph Deturris: novelties.

Sometime in the late 1960s, the park, now commonly referred to as "AI," changed owners and shifted its focus from that of a kiddie park into a large-scale amusement park. Harold Glantz and Martin Garin purchased it and added major rides like the Galaxy, Jet Star, Jumbo Jet, Toboggan, bumper cars, Batman Slide and the Flight to Mars. It is believed that the garbage cans around the park were from the 1964 New York World's Fair, which was held in the nearby Flushing Meadows–Corona Park, and that some of the rides brought in during the expansion may have come from the Palisades Amusement Park in Bergen County, New Jersey, which closed in 1971. One ride likely transplanted from Palisades was the Flight to Mars, a funhouse/house of horrors–type ride where riders would travel in cars along a track through a two-story journey past various aliens and other scary characters. Versions of this ride also existed at Coney Island, Gaslight Village in Lake George and Fun Forest Amusement Park in Seattle, Washington. One unusual aspect of the ride at Adventurers Inn was the fact that the large sign at the top of the ride had a typo and incorrectly read, "FLIHGT to Mars."

In 1973, the *New York Times* wrote a story about how local residents living nearby the park were disgruntled by its expansion. Neighbors complained that the enlarging of the park led to an increase in traffic, noise, littering and crime. While no criminal activity was directly connected to the park, one resident compared the park's evolution from a kiddie park to a full-fledged amusement park to be like a "cancer." Residents of the Linden Towers Co-Op No. 4 and the local community board began actively protesting any future expansion of the park and tried to get its lease terminated. It was the dispute with these active residents that ultimately led to the park's demise.

The city clearly was supportive of the park's closure; by the late '70s, the property had been taken through eminent domain by the New York Public Development Corporation to be made into an industrial development. The property was vacant for many years. Today, it is home to a large complex containing the College Point Multiplex movie theater, Toys R Us, Office Depot and office buildings.

Queens Parks

Auer's Kiddie Park

Beach Ninety-seventh Street, Rockaway Beach • 1923–1956 • LOST

At the turn of the twentieth century, the Rockaways section of Queens was in competition with Coney Island for being the favorite summer resort area of New York. Rockaway Beach was full of various amusements, bathing pavilions, bars, restaurants, hotels and a boardwalk, as well as miles of sandy beaches. The Rockaway Chamber of Commerce marketed the area as "Where New York City's Ocean Begins." The Rockaways includes the areas of Arverne, Belle Harbor, Edgemere, Far Rockaway, Hammels, Hollands, Neponsit, Rockaway Park, Seaside and Steeplechase.

Tent camps became extremely popular in this area, where beachgoers would rent out tents for a week or for the season while they enjoyed the beach and nearby amusements. Tents were made of waterproof canvas and had wooden frames and floors that could be set about eight inches above the sand. The structures were fortified so that they could withstand rain and storms. Tents were of various sizes, some with multiple "rooms" divided by canvas partitions. The tents could be furnished with beds, chairs, tables, camp lights and gas stoves for cooking, with gas provided.

One such tent camp would become the site of the L.A. Thompson Amusement Park (later Rockaways' Playland) in 1902. William Auer had

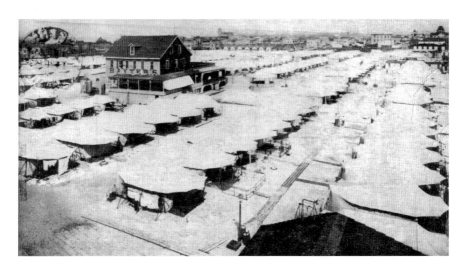

Rental tents in the Seaside area of Rockaway Beach that were similar to those owned by William Auer. Postcard mailed to Yonkers in 1912. *Author's collection.*

Historic Amusement Parks of Long Island

been active in the amusement and resort industry since 1903 and was running William E. Auer's Kiddie Park, Camps and Cottages soon after. When Thompson's park underwent a massive expansion, Auer lost the part of the property where he was operating his tent rental. Around 1923, Auer focused on the rides and amusement aspect of his operation and opened a new kiddie park in what would become Auer Midway Park on the north side of the boardwalk. He joined with another kiddie park owner, Morris Kraus, who had run a park between Beach Ninety-third and Ninety-fourth Streets.

This new kiddie park was on Beach Ninety-seventh Street in Rockaway with a handful of rides, including a small carousel, Whip, an airplane, a Ferris wheel, Chair-o-Plane, a boat ride, an army tank and a pony cart ride. The park and tent colony were directly across from Thompson's park on the opposite side of the boardwalk. Auer had other amusements at the park to entertain his young visitors, including two rhesus monkeys, Pat and Oscar, that he rented from a Manhattan shop during the summer of 1936. In October of that year, soon after the warm weather business began to die down, Auer brought the monkeys to his home before returning them to the shop. The *New York Times* reported that the two escaped from their cage and out of the house through an open window. Auer set up a trap with fruit hoping to lure the animals back when they got hungry. Pat was caught quickly, but Oscar remained missing for over a week. Oscar was well fed

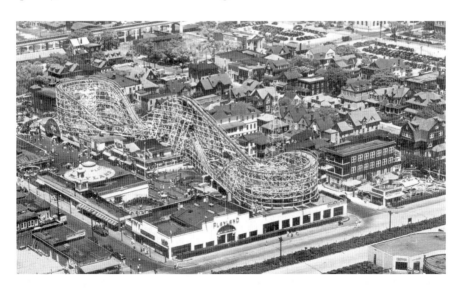

This aerial view of Rockaway Playland in 1945 also shows Auer's Kiddie Park. Note the park to the right of the roller coaster. *Courtesy of the Rockaway Chamber of Commerce / the Queens Borough Public Library, Long Island Division, Illustrations Collection–Seaside.*

during this time, however, as nearby residents reported that their back porch iceboxes were being raided during the night.[10]

When Robert Moses began construction on the Shorefront Parkway, the kiddie park was in its path and ultimately was reduced by two-thirds. Auer's tent colony, which was still in operation, was down to only a handful of rentals from a camp that had once held over 150 tents. So much of this area was razed by the city for Moses's plans. Around 1939, Auer decided to close his park and sell off all of his rides, most likely due to the effects of World War II. By the fall of 1943, it was clear that Auer regretted this decision because he bought back all of his rides and returned them to the same exact location. In the late 1940s and into the early 1950s, Auer was in competition with the numerous other kiddie parks in the area, including Joytown and Nunley's Rockaway Beach (see "Joytown" and "Nunley's Rockaway Beach" sections).

Auer continued operating the park for a few more years, but he ultimately decided to retire in 1954. He sold off his entire seven-ride park while retaining the property. The rides were purchased in 1956 by M.D. Borelli, who operated Sunset Beach in Almonesson, New Jersey, a "resort area" that offered other rides, boating, picnic areas, dancing and bowling. By 1965, the site that had once been the kiddie park was now a parking lot. Today, apartments are located on this beachfront property.

Fairyland Park

Queens Boulevard, Elmhurst • 1949–1968 • LOST

When Fairyland Park first opened in June 1949, it was a small kiddie park located on Horace Harding Boulevard near Queens and Woodhaven Boulevard. The owner, Bernard Berkley, sold the property to developers working on a new large-scale apartment building (today Lefrak City). Months later, Fairyland was relocated to a better site, where it became a full amusement center and restaurant that began operating in November 1950. Now located on the busy location of Queens Boulevard about two hundred feet east of Woodhaven Boulevard, it was built at a cost of $600,000. The park could hold 8,000 people, with parking for one thousand cars. It was easily accessible by car, bus, subway and foot. During the early 1950s, Elmhurst had a residential population of around 500,000 people, many of whom were families with small children living within walking distance.

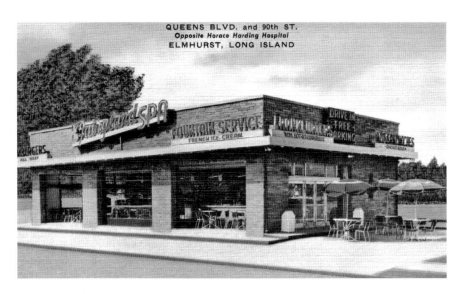

A postcard for the restaurant next to Fairyland Park in Elmhurst, Queens. The card boasted that the drive-in had "a complete selection of fountain specialties." *Author's collection.*

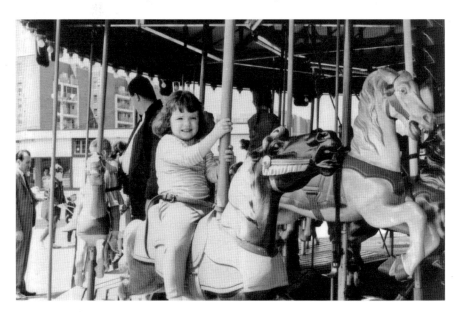

Riding the carousel at Fairyland in May 1965. *Courtesy of Karen Pavone.*

Originally, the site was to be the home of a new arena run by Ringling Brothers and Barnum & Bailey Circus, which was in a contract debate with Madison Square Garden, but these plans fell through.

Open year round, the park had fourteen rides, including major rides like a Comet Junior wooden roller coaster and large Ferris wheel—a No. 16 Big Eli—but the focus was on its numerous kiddie rides. Kiddie rides included large and mini carousels; a Pinto Bros. Ferris wheel and fire engine; Herschell Sky Fighter, water boat ride and jeeps; Mangels Whip; a dry boat ride; and a pony cart. There was no admission fee or charge for parking. Ride tickets were fourteen cents each, or five for forty-nine cents. During the warm months, the park hours were 10:00 a.m. until 10:30 p.m.

The park added an arcade in 1951 that adjoined the restaurant: Fairyland Spa. The restaurant had a dramatic neon-lit façade facing Queens Boulevard with terraces and umbrella-shaded tables. It was this substantial food operation that helped bring visitors to this park over its competitors, as well as its location in a residential area on a busy road. This park was one of the most successful in the country, averaging around $250,000 annually, partially due to its year-round weekend operation. The park could bring in as many as fifteen thousand people on a Sunday during peak months. The most popular rides were the roller coaster, train and carousel.

Fairyland began a large marketing campaign and would spend around $40,000 a year on advertising. Part of its campaign was to form collaborations with food suppliers targeted toward children and to distribute free tickets, as well as posters, in subways and on buses.

Kiddie ride tickets from Fairyland Park. *Courtesy of Joseph Kuceluk.*

Historic Amusement Parks of Long Island

Fairyland's kiddie roller coaster. Note the signage painted on the brick walls in the background. *Courtesy of Karen Pavone.*

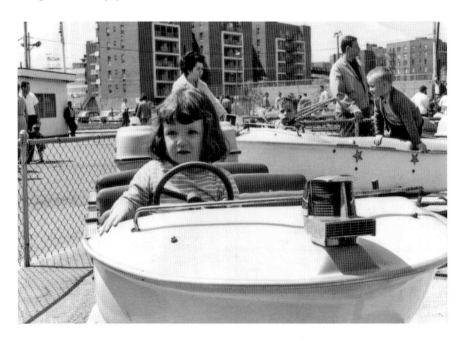

The wet boat ride at Fairyland with a rider in the background trying to make an escape. *Courtesy of Karen Pavone.*

Queens Parks

In May 1954, in order to attract teenagers and adults to the park, owners added three new major rides: a Sellner Tilt-a-Whirl and an Eyerly Octopus Fly-o-plane and Rock-o-Plane. Eight thousand square feet were added to the park to accommodate the additions, as was a new nine-hole miniature golf course, to be operated by Phillip and Meyer Goldstein's Pace Amusements firm, which maintained five other courses in the New York City area, including ones in Bayside and Rego Park.

Although the addition of these adult rides had the potential to compete with the family atmosphere at this predominately kiddie-themed park, the manager, Alfred McKee, kept the adult rides together at the rear of the park—with the exception of the Ferris wheel and roller coaster, so they could be spotted from the street along with the park's forty-foot title sign. He also felt that his large operating staff (twenty-five people during busy times) would prevent any potential teenage disturbances, as would the fact that families tended to come to the park earlier in the day while adults and teens came in the evening.

In 1955, owner Berkley sold the park's arcade operations to John Glick and Phil Phillips, who began operating it as P&G Arcade. He also added three new kiddie rides, all by B.A. Schiff: Aerial Swing, Cadillac Car and Kiddie Coaster.

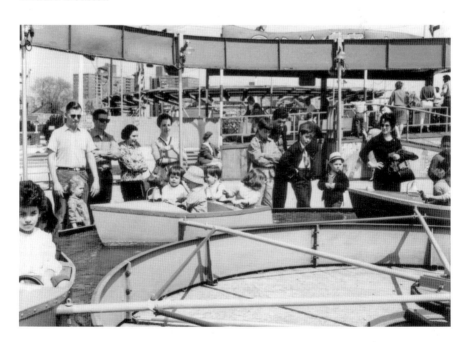

A crowded day at the park causes long lines for the wet boat ride. *Courtesy of Karen Pavone.*

The name of the park became a source of stress in 1956, when the owners tried to prevent the "Fairyland" park in Brooklyn from continuing to use the name—but to no avail. Another headache for the owners came in the form of a fire. An article in *Billboard* from November 1957 reported that a fire beneath the large roller coaster burned the park's maintenance shop to the ground, causing over $12,000 worth of damage to the building and the ride.[11]

The heavily populated area of Queens was full of apartment houses occupied by families with more than one child, so the park had high visitation numbers even during the cold-weather months. The park was clearly doing well. In June 1959, three robbers broke into the closed park and stole a two-hundred-pound safe containing around $6,000. The night watchman was tied up by the robbers but was eventually able to escape his bonds and call the police.[12]

Even though the park was successful, property value won out. Fairyland closed its doors in 1968. Today, the space that was Fairyland is currently the site of the Queens Center Mall, which officially opened in September 1973.

Joytown / Rockaways' Playland Kiddie Annex

Beach Ninety-eighth Street • Rockaway Beach • 1949–1985 • LOST

Rockaways' Playland was located on Beach Ninety-eighth Street and was founded around 1901. It was originally known as the L.A. Thompson Amusement Park and was owned by LeMarcus Thompson, the so-called father of the roller coaster. The name officially became Rockaways' Playland in 1928, when the park changed owners and was purchased by A. Joseph Geist, a former attorney. It originally extended out to the boardwalk that adjoins the beachfront but was greatly truncated in the late 1930s with the construction of Robert Moses's Shore Front Parkway. It is probably most famous for its roller coaster, the Atom Smasher, which was famously featured in the film *This Is Cinerama* in 1952.

Back in 1948, however, A. Joseph Geist, the president of Rockaways' Playland, began developing a kiddie park that was located opposite and diagonal from Playland's entrance. The park was fifty thousand square feet, located between Beach Ninety-eighth and Ninety-ninth Streets from

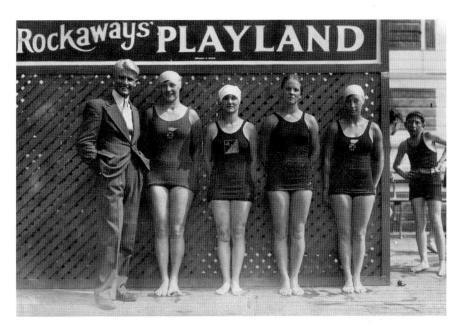

Swimmers pose near the park. *Courtesy of Queens Borough Public Library, Long Island Division, Emil R. Lucev Collection.*

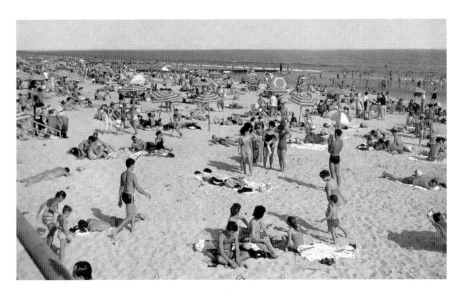

"Enjoying surf, sun and sand at Rockaways' Playland." A postcard promoting the eleven miles of beach near the park. *Author's collection.*

Historic Amusement Parks of Long Island

Rockaway Beach Boulevard to the Freeway. Geist planned a $40,000 modernization project for the kiddie park in order to make it a kiddie annex to the main park. The kiddie park had slightly different hours than the main park, generally opening earlier and closing earlier on weekends. The park had a miniature railroad, a carousel, a boat ride, a carriage ride, a rocket, fire trucks, speedboats, jet planes and a Whip. Later that same year, Geist purchased two additional rides from the Allan Herschell Company: a Sky Fighter and a kiddie roller coaster. There was also a penny arcade. Around this time, the Long Island Railroad offered a special round-trip rate to the Rockaways from Manhattan: $0.75 for adults and $0.35 for children, compared with $1.52 for both adults and children.

The kiddie park addition was extremely successful and reportedly brought in 40 percent of total visitation numbers for Playland during weekday afternoons. The new addition was part of a $50,000 expansion of the park, which included the new kiddie area and two large rides in the main park: a Bubble Bounce and a Rock-o-Plane. Other improvements at this time included the enlargement of the Beach Ninety-eighth Street entrance; an updated public address system by Hughes Sound System; a new fluorescent lighting system; a five-foot "wishing well," the coins of which would be donated to the Heart Fund charity; and a forty-foot rock garden.

In 1952, Geist added four new rides: Kiddie Turtle, Jet Racer, Kiddie Jeep and Bulgy the Whale. He also added Sugar-Coated Candy House—a twenty-six-foot-tall house inspired by Hansel and Gretel. Playland's art director, Herman Huseby, designed the house. All of the street lamps within the park were also redesigned with red and white stripes to resemble candy canes. The entire park continued to be successful through the 1950s and '60s with updates to rides and amusements and special events like beauty pageants. However, the neighborhood was changing, with summerhouses becoming residences for year-round living.

By the 1970s, the park's attendance was beginning to decline, and the kiddie rides were moved into the main park. Rockaways' Playland officially closed around 1985 after huge insurance premiums made it too expensive to operate.

Queens Parks

Kiddy City

Northern Boulevard, Douglaston • 1954–1964 • LOST

The million-dollar Kiddy City opened on May 1, 1954. This unusually large park was twenty-five acres—a rarity to find so much open space so close to Manhattan and so ideally located close to parkways and bridges. At the time, it was the third-largest amusement park in New York City, behind Steeplechase in Coney Island and Rockaways' Playland. Getting the park up and running proved difficult. First owner Dave Simon had to purchase all of the plots to make up the site—and there were some twenty different owners. Early plots were purchased for around $40, but when other owners became aware of the future plans for the land, they upped their prices. According to a report in *Billboard* magazine, one owner ultimately received $40,000 for his key acre of property. Once all the property was finally purchased, more problems developed. The property was swampland and required thousands of yards of fill, which was a challenge because the muddy ground kept absorbing the new dirt. Then there was a sixteen-week strike by building supply drivers. And finally, the original plans included a children's zoo in the park, but then an approved variance was reversed and that idea had to be dropped.

Kiddy City offered free admission as well as parking. Located at Northern Boulevard and 230th Street, it was between the towns of Douglaston and Bayside. Advertisements from 1954 list the park as "Kiddy City," but it could also be found listed as "Kiddie City." The park had twenty-four rides, as well as an eight-unit baseball batting cage with a 50-foot-high backdrop, arcade and archery range. There was a 100-square-foot restaurant building that housed the arcade, and there was a 350-foot-long Homes-Cook nineteen-hole miniature golf course called Golfland that opened before the rest of the kiddie park at fifty cents a player. The park didn't have any major food concessions, just some counter refreshments. The owners said that they did this purposely so as to not take business from local restaurants. Some of the kiddie rides included Jeepmobile, a junior Ferris wheel, pony carts, Herschell Sky Fighter, tanks, jeeps, a boat ride, a small carousel, Hodges handcars, Pinto fire trucks, Chamber's Bug ride and Toonerville Trolley. Larger rides included a Philadelphia Toboggan Company Carousel, an Eli No. 16 Ferris wheel, Tilt-a-Whirl, Whip, a Lusse Bros. scooter, Roto-Whip and a National's Century Flyer roller coaster with 2,700 feet of track. There were different ticket prices for kiddie rides and larger rides, ranging from fifteen cents to twenty-five cents each.

Historic Amusement Parks of Long Island

Bill de L'horbe Jr. of the National Amusement Device Company and architectural designer Charles Spector designed the park. It was designed with flexibility in mind so that rides could be relocated within the space. The entire grounds were wired with the capacity to power each potential ride in various layouts. The design also accounted for covered walkways between rides so that the park could still run in inclement weather. The layout of the park was also designed so that major and kiddie rides were kept separate. The park's manager, Bob Black, felt that the staff kept the park in order from rowdy teens.

In 1954, a hearing took place to fight the proposed establishment of a rival kiddie park directly across Northern Boulevard from Kiddy City. The park, to be run by Missouri Enterprises, was being opposed by local civic groups that felt the location would cause traffic bottlenecking, which was a potential danger to children who would be in the area for the parks. Traffic had already been significantly affected by the park's opening, even leading to the owners purchasing and installing their own traffic light on Northern Boulevard to help control traffic entering and exiting the park. On December 18, after numerous postponements, the Board of Standards and Appeals denied Missouri Enterprises' application. A rival park would not open.

Owner Dave Simon passed away in 1963, and Simon Sales was taken over by Irving Holzman to become United East Coast Corporation. In 1964, the restaurant caught fire and forced the park to shut down. The company lost its insurance and had to close. Some rides remained to decay at the park for a few more years. The remaining pieces of the park were eventually removed to complete Alley Pond Park. The Alley Pond Golf Center is currently in operation near the location of the now lost Kiddy City.

Kiddie Park / Dreamland Kiddie Park

Horace Harding Boulevard, Fresh Meadows • 1950–1955 • LOST

Max Gruberg, previously a carnival operator in the Philadelphia area, was successfully operating Long Beach Kiddie Park (see the "Long Beach Kiddie Park" section) and decided to expand his business by opening a park in Queens. He purchased property at Horace Harding Boulevard and 174th

Queens Parks

Street and spent about $70,000 to develop the park. Rides included a rocket, a train, Chair-o-Plane, a boat, a buggy, Roto-Whip, a fire engine, a Ferris wheel and a carousel. There were some concessions in the park, as well as skeeball. In April 1950, Gruberg officially opened Kiddie Park, and although the weather was poor, there was reportedly a crowd of twenty thousand on opening day causing traffic jams. Gruberg charged the same ticket prices at all his parks: nine cents each or three for twenty-five. He also sold season ticket books for ten dollars. The neighborhood was clearly excited to have its own kiddie park because Gruberg reported selling $900 in tickets the first Sunday of operation. Local merchants, civic groups and schools also began reaching out to him for collaborations and promotional events.

This Queens park was more successful than his Long Beach spot but was significantly more challenging to maintain due to the fact that it was within New York City. At this park, he now had to meet zoning ordinances, constant city inspections and higher labor costs. In 1952, Gruberg decided to reenter the carnival industry and leave his wife in charge of his New York kiddie park operations.

By June 1953, Gruberg had sold the kiddie spot, and two new owners were now running the park. Albert Seyman and Frank Sadowski, who had recently opened the five-ride Dreamland Kiddie Park on Hillside Avenue in Brooklyn, decided to add this second park to their business. It appears that the majority of the original rides were purchased along with the park itself.

In 1954, a Queens resident tried to have the kiddie park shut down for alleged violations of the Sabbath law, but all charges were dismissed. The case was most likely brought to court because the neighbor who brought the suit lived in a house about fifty feet away from the park and was bothered by the noise. That same year, the owners were met with another challenge. Plans were beginning to go into effect to widen Horace Harding Boulevard for the following fall, which would force the park to be relocated—a possible explanation for why Gruberg might have wanted to get rid of the park if he had heard rumors in the industry. The owners considered closing the park before the next season but decided instead to increase the number of rides they had. Seyman and Sadowski decided that when they were forced to close their Queens location in July 1955, they would consolidate their rides and focus on their Brooklyn park. However, by September 1955, the owners had placed an advertisement in *Billboard* magazine selling the entire park's contents or individual rides because they now "ha[d] other interests."

Historic Amusement Parks of Long Island

Nunley's Rockaway Beach and Broad Channel Amusements

Beach Ninety-eighth Street, Rockaway Beach and Cross Bay Boulevard, Broad Channel • ca. 1930–1959 • LOST

William Nunley was a third-generation amusement park entrepreneur from Staten Island. Born in September 1888, Nunley first made his mark in the amusement business when he ran a park known as Nunley's Happyland in the South Beach area of Staten Island. He also operated numerous carousels in the New York City area—all attempts to compete with the popular amusement areas in Coney Island. Nunley would soon move into the kiddieland business, and he owned five parks across New York in Broad Channel, Rockaway Beach, Yonkers, Baldwin and Bethpage (see "Nunley's Amusement Park" and "Nunley's Happyland" sections).

Nunley saw the potential for amusement park success in the Rockaway Beach area of Queens, so in 1914 he established a carousel in the Seaside

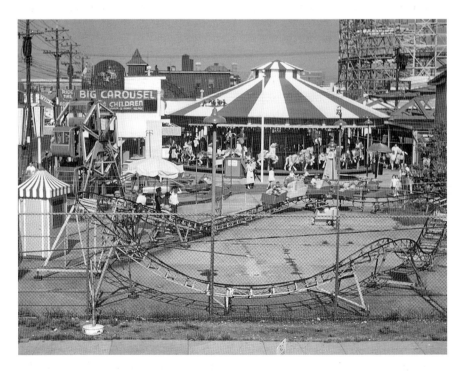

The rides at Nunley's Rockaway Beach kiddie park, including the Ferris wheel, carousel and roller coaster. *Courtesy of Dennis Ciccone Jr.*

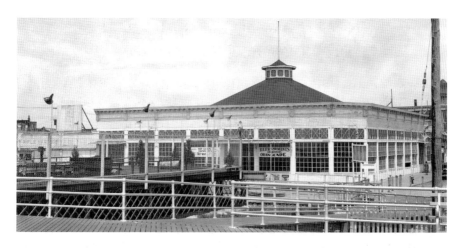

The carousel pavilion at Nunley's Rockaway Beach. The sign on the building at left reads, "Rifle Range." *Courtesy of Queens Borough Public Library, Long Island Division, Emil R. Lucev Collection.*

area of Rockaway. He eventually moved the carousel to another site, which was down the street from Rockaways' Playland. The carousel was located at 171 Beach Ninety-eighth Street. Nunley soon added kiddie rides like a fighter plane, a Ferris wheel, a miniature railroad, a boat ride, auto rides, a pony ride and a roller coaster, and a park developed around what began as just a carousel. He named his park Nunley's Rockaway Beach.

William Nunley joined together with other property owners and concessionaires to form the Rockaways Carnival Association in 1935. This group was created to advance the interests of the amusement section of the Rockaways. Though this group joined together to promote the amusement business in the area, there was a great deal of competition among the many parks operating in such proximity. Ride ticket price wars were a constant occurrence, with prices fluctuating between eight and ten cents each.

In the 1930s, Nunley also opened a carousel operation in the Broad Channel area of Queens, only a few blocks away from his Rockaway Beach Park. Nunley owned a large tract of land with a carousel pavilion. Aside from the carousel, this building contained a boat ride and sixty arcade games and coin-operated machines. Nunley's Broad Channel Amusements was located on Cross Bay Boulevard—then known as Jamaica Bay Boulevard at the bridge over Jamaica Bay. The building was highly visible, as it was situated on the main approach to the Rockaway resort area. Also, it was directly across the street from Weiss's, a popular restaurant with heavy summer business.

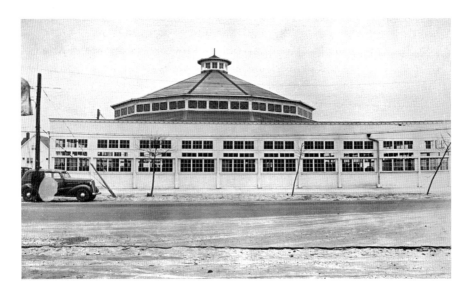

Above: The Nunley's Broad Channel carousel pavilion, featured here, was used as a model when Nunley was building his Baldwin park. *Courtesy of Nassau County Department of Parks, Recreation & Museums, Photo Archives Center.*

Left: Traffic along Jamaica Bay Boulevard heading toward the beach. The Nunley's carousel pavilion is at left. *Courtesy of MTA Bridges and Tunnels Special Archives.*

William Nunley died in 1951, and his entire kiddie amusement business was taken over by his wife, Miriam. She ran the five kiddie parks, as well as over thirty rides and concessions at other parks in the area. Soon, she began to focus on the more profitable parks in Baldwin and Bethpage and the concessions they were running throughout the island. Much of the surrounding property at Broad Channel was underdeveloped, so in 1955, Miriam Nunley sold this park and its land. The park had a large carousel with forty-eight horses, three-abreast style, with two coaches and two boats, which she replaced with additional horses. Miriam decided to bring this carousel to Nunley's Happyland in Bethpage, which had a smaller carousel made up of forty-four horses staggered two and one. The Rockaway park closed sometime around 1959. The rides and carousel were auctioned off.

Playland Center / Cross Bay Amusement Park

Cross Bay Boulevard, Howard Beach • 1952–1990s • LOST

Playland Center opened in the fall of 1952 on Cross Bay Boulevard and 164th Avenue. The kiddie park opened with seven kiddie rides, including a wet boat ride, a train ride, a Ferris wheel and Whip, later adding a Schiff roller coaster. In 1955, the park tried to gain new customers with the employment of an entertainer named Sunshine. Sunshine, a seventy-two-year-old retired clown, would walk through the park entertaining visitors. Howard Beach was not actually the original location planned for the park. The owners, Irving Greenfield and Gabriel DiTillio, were about to open a kiddie park with the name Playland Center in 1951 on Bruckner Boulevard in the Bronx when they discovered an issue with zoning. The owners then found the Queens location and continued with their plans. This new site, which was a prominent location for traffic entering the Rockaways Beach area, was also home to other amusement facilities, most notably Rockaways' Playland.

In 1954, Playland Center became involved in a lawsuit regarding title exclusiveness for the park's name. The case was made by the owners of Rockaways' Playland, who objected to the new kiddie park using the name "Playland" and the figure of a clown's head in its signage. Rockaways' Playland attorneys argued that the original park had already

Historic Amusement Parks of Long Island

A painting of Cross Bay Amusement Park by local artist Madeline Lovallo, as seen from Cross Bay Boulevard. *Madeline Lovallo, madelinesstudio.artistwebsites.com.*

spent more than $1 million in marketing and had been in operation for over twenty-five years. They also felt that the new park was taking advantage of its proximity to the existing park and trying to capitalize on the latter's success. However, the park fought and soon won an appellate court permission to retain its name. Playland Center owners stressed the fact that they were originally to open their park in the Bronx with their company name and moved to the site in Queens because it was available, not due to its proximity to the other park. They also pointed out that the two parks were over five miles apart. The battle continued, and in 1956, the courts decided that while "Playland" is a generic term, the word could not be used by a competing business in the same area. Soon after, the park was listed as "Kiddie Park," and by 1959, its name had been officially changed to Cross Bay Amusement Park.

The amusement park closed around 1993. The site eventually became a Staples, which was damaged during Hurricane Sandy in 2012.

Queens Parks

Wonderland Farm Zoo

South Conduit Avenue, Ozone Park • 1952–ca. 1960 • LOST

Wonderland Farm Zoo opened in Ozone Park in May 1952. The kiddie park occupied a plot of land off South Conduit Avenue near the entrance to Idlewild Airport, which became John F. Kennedy International Airport in 1963. Two couples, Joe and Anne Lange and Joe and Sarah Lewis, owned the park. The petting zoo housed tame barnyard animals, some contained within a 175-square-foot enclosure and some that walked freely among the visitors. Animals included pheasants, pigeons, geese, ducks, rabbits, goats, ponies, pigs, squirrels, deer, a donkey, a spider monkey, a calf and a chimpanzee. The owners raised all of the animals from infancy, so they were completely domesticated and used to people. Animals were purchased from farmers in upstate New York and were handfed by the owners, who trained at the Bronx Zoo to learn how to best care for them.

The property had a barn and an office building containing the restrooms, both twenty square feet in size. It also had kiddie rides, including a Chair-o-Plane, Roto-Whip and coin-operated rides like a jeep and a fire engine. There was a candy counter and soda vending machine, and the outer fences were decorated with Masonite animal figures. The park had a storybook theme; the displays housing the animals referenced nursery rhymes like "Three Little Pigs" in houses of straw, sticks and brick and "Mary's Little Lamb" at the schoolhouse.

Each animal section had painted signs with information about the animals, like their names, breeds and birthdays. For example, a sign above a sika deer read, "Felice / Born June 19, 1952." A sign reading, "Maternity Ward" was above the rabbit dens. Two raccoons had a poem above their enclosure that read, "Rickety and Rackety our pet raccoons, / fell madly in love one day in June, / he wooed and won his lady fair, / and brought her to "Wonderland," his home to share." One of the challenges of this park was the maintenance of its structures and decorations due to the strong winds coming off the airport from Jamaica Bay.

Admission was thirty cents for visitors over two years old, with additional charges for pony cart rides and all other kiddie rides. The biggest moneymaker at the park was the selling of feed for the animals at ten cents a bag. A good weekend day could see as many as two thousand visitors. The park was so successful that its owners were able to completely pay off their backers after two years of operation.

Historic Amusement Parks of Long Island

To help publicize the park, the owners advertised in Long Island newspapers and on radio stations. They also made guest appearances on kiddie TV shows with their animals. One of the most popular animals at the park was their chimp, which would perform in a display that had seating. During the holiday season of 1953, Wonderland held a photography contest that asked applicants to submit pictures of animals and children at its zoo. The ten winners would have their photographs on display at the park, as well as receive a baby animal of their choice.

There is no record of the park after 1955. It was most likely displaced during the airport's development during the 1960s.

Worth Mentioning

These are parks that I came across in my research but couldn't find much information on—do you remember?

Cinderella Kiddie Park

Thirty-second Street, Edgemere • 1951–1954

Operators: Morton Speicher and Harry Lubell
Manager: Charlie Fishman
Six rides: a miniature train and five Herschell rides—a carousel, Sky Fighter and auto, boat and pony rides; plans to add a Ferris wheel

Midway Kiddie Park

Ocean Drive, Rockaway Beach

Owner: Pete Drambour
Manager: Fred Draudt
Modern Skooter building, a carousel and Whip
Refreshment stands on its Seaside Avenue front and a building that housed games

Chapter 3
NASSAU PARKS

Nassau County is the first county east of New York City and is considered to be suburban. This area began to see a huge surge in development and new residents immediately following World War II as returning veterans looked to leave the city and move to the suburbs. With this influx of new residents, many amusement parks, particularly those geared toward young children, began to develop.

Adventureland

Route 110, Farmingdale • 1962–Present •
www.adventureland.us

In the late 1950s, friends Alvin Cohen and Herb Budin decided to get into the industry of amusement parks that was booming across Long Island. In 1960, Cohen and Budin purchased from a chicken farmer a six-acre site in East Farmingdale on New York Route 110 for $137,000. In 1961, the owners began constructing their million-dollar park. When the park first opened, one feature was a large building containing a restaurant, arcade and four rides, including a Dentzel carousel, allowing the park to have year-round operations. Outdoors, there was a miniature golf course, kiddie cars, boats, a miniature train that covered a half mile of park grounds and a

Historic Amusement Parks of Long Island

Herschell Little Dipper roller coaster. In 1962, the park opened as Adventures 110 Playland, but a few months later, the park was being advertised as 110 Adventureland. The park's gala grand opening was on Saturday, July 14. Special guests included TV characters Popeye, Brutus and Captain Jack McCarthy; Delmonte's chimps; jugglers; Clem Basile's Carnival Band; and trampoline comics, along with many free gifts and specials. The park was in operation every day from Easter to Labor Day and on weekends in good weather during the rest of the year. There was a parking lot for one thousand cars, and the park employed around 150 workers.

The park's restaurant, the Adventurers Inn, was prominently featured in advertisements along with the park or on its own. Ads boasted that it was an "all-year, all-weather restaurant and amusement park." Featured food included hamburgers, hot dogs, fried chicken, turkey chow mein, Blue Point clams, sandwiches, ice cream, sodas and malts. The restaurant boasted that all baking was done on premises and that catering services were available. There were daily specials in the restaurant for fruit pies, pints of ice cream and cakes—all freshly baked. There were also promotions where guests would get free ice cream pops or pencil boxes with newspaper coupons.

The park had various shows and events. In March and April 1964, the U.S. Army provided free shows to guests, offering demonstrations and displays of weapons and machinery. That same year, television star Davey Dixon and his horse, Honey Girl, provided western-themed performances at the park. In 1965, the first major ride, the Skyliner, was added; it traveled the entire length of the park. By the 1970s, Cohen had purchased an additional six acres, at a cost of around $500,000, and began a massive expansion, doubling the park's rides to thirty. It was at this point that the original focus of kiddie rides began to shift to rides for an older audience. Cohen purchased multiple European-manufactured rides from an importer named William Miller. Miller, from Germany, ran Continental Park Attractions Inc. and imported, leased and operated rides across the country. In September 1977, Miller purchased the park. Under Miller's ownership, he shortened the park's name to Adventureland and continued to add new European rides, bringing the total number from nineteen up to twenty-four rides.

Many changes were made to the park, including the introduction of "POP"—"pay one price" for unlimited-ride ticket packages. There were laser shows and a radio station broadcasting from the park, and Miller began marketing Adventureland as the "Playworld of Long Island." To celebrate the twentieth anniversary of the park, Miller held numerous promotions and events, including a "Filipino Friendship Weekend" in collaboration

with the Filipino consulate general. In 1984, a Bavarian Village was added, with food kiosks, shops and a photo emporium. This new area marked the beginning of a transition to a theme park–style venue. Miller was constantly modifying the park and adding rides, but in the mid-'80s, he began updating the style of the park by replacing the blacktop with stonework, landscaping and adding wrought-iron fences.

In 1987, Miller sold the park to Tony Gentile, who had been an investor in the park since 1978. The Gentile family continued to expand the park and added a new midway called "Pirate's Plaza." In 1991, a new 1,430-foot-long roller coaster, the Hurricane, was added to the park. Old rides were constantly being replaced, and in 2003, the kiddie boat ride—the last original ride in the park—was replaced with a new boat ride called the Viking Voyage.

In 2009, Miramax Films released the movie *Adventureland* starring Jesse Eisenberg and Kristen Stewart. The film was written and directed by Greg Mottola, of Dix Hills, who based the story on his experiences working at the park during the 1980s. The year 2012 marked the fiftieth anniversary of the park. A new mascot, Alfie Adventureland, was introduced to celebrate the anniversary, as were a new stage, rides and games. Today, Adventureland has twenty-six rides and a kiddie area with family-friendly rides.

Frank Buck's Jungle Camp / Massapequa Zoo and Kiddie Park

Sunrise Highway, Massapequa • 1934–1965 • LOST

Frank "Bring 'Em Back Alive" Buck was a household name on Long Island and throughout the entire country from the 1920s through the 1940s. Buck was a world-renowned animal hunter and collector of exotic animals for circuses—including Barnum and Bailey and Ringling Brothers—from his travels around the world. A writer, producer, director and film actor, he starred in a number of movies about his expeditions, including *Bring 'Em Back Alive* (1932), *Wild Cargo* (1934), *Jungle Cavalcade* (1941) and *Africa Screams* (1949). In 1934, at the Chicago's World Fair, Buck set up an exhibit of the animals he had collected in his travels. Frank Buck's Jungle Camp was a replica of the camp he had lived in while in Asia, and it saw over two million visitors. When the fair closed, Buck moved the entire camp to Long Island.

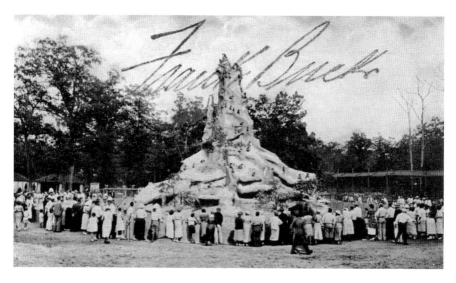

Above: A postcard featuring one of the park's main attractions: Monkey Mountain. This feature remained at the park after it was purchased by new owners. *Collection of Gary Hammond.*

Left: A souvenir book for the Frank Buck's Jungleland exhibit at the 1939 New York World's Fair in Flushing Meadows Corona Park. *Author's collection.*

Frank Buck's Jungle Camp was forty acres and housed hundreds of lions, elephants, tigers, monkeys, reptiles and other wild animals in a zoo on Sunrise Highway at the eastern end of Massapequa, near the Amityville border. Buck and partner T.A. Loveland leased the property from an Amityville man who owned a lion house. Many of the animals came from the collection of Charles W. Beall, an Oceanside man who owned a private zoo on Mott Avenue in the late 1920s. There were multiple buildings on the property, including a three-story, Tudor-style building—the Frank Buck Hotel—as well as a restaurant and other stores. Small animals and wild birds were housed in this building, along with posters and photographs of Buck during his expeditions.

The press loved the camp, and many stories were written documenting new arrivals and animal births. On February 23, 1936, the *New York Times* reported that cheetah twins were born at the camp and were declared to be the first born in this country[13] and on May 25, the paper reported that cargo from Singapore arrived at the camp, including king cobras, leopards, three pythons, nine bears, fifty monkeys and over three thousand birds.[14] The *Times* articles were highly dramatic, reporting on the ferociousness of the animals and mishaps by animal handlers and listing the human kills in their native countries. In 1936, Frank Buck himself was constantly in the paper for injuries and illnesses. A frequent visitor to Reed General Hospital in Amityville, Buck was admitted in September for a reoccurring gastric disturbance due to drinking polluted water in the Malay jungle during a past expedition[15] and then in October for injuries to his right arm and leg after being trampled by a rodeo horse he was attempting to mount.[16] He was also reportedly bitten by a python,[17] and his staff members were admitted

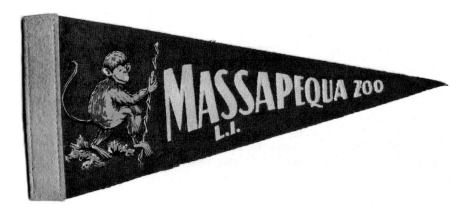

A pennant from the Massapequa Zoo and Kiddie Park. *Collection of Gary Hammond.*

for various animal attack injuries over the duration of the zoo's operation as well.

The most reported incident of all took place on August 21, 1935.[18] About noon, 150 of the 570 rhesus monkeys in the seventy-five-foot-tall Monkey Mountain exhibit at the center of the property escaped when a worker accidentally left a wooden plank across the moat. Camp worker Charles Selner had entered the exhibit for cleaning and repairs by way of a plank across the eight-foot-high surrounding wall to the cavern platform. Three minutes later, he returned to the makeshift bridge only to discover dozens of monkeys making their getaway. Staff and visitors watched as monkeys poured through the camp, and they were able to stop only a handful; the rest escaped the camp and made their way along Sunrise Highway. The monkeys caused some damage and general surprise in the nearby area. About fifty were successful in delaying an eastbound Long Island Railroad train that had just left Massapequa for Seaford by gathering on the tracks; unfortunately, two were electrocuted by the third rail. And two others climbed a high-tension tower of the Long Island Lighting Company near Hicksville and were electrocuted, causing temporary service interruptions. Thirty-five clustered on Seaford Avenue near Merrick Road, causing a local resident to crash into a tree. The monkeys, ranging from five to ten pounds and valued at around fifty dollars each, were considered harmless. While thirty returned of their own accord by sunset, over one hundred were still missing the first night. Most of the monkeys survived and were returned by the police and local residents in the following days. Frank Buck and his wife were on an expedition in the Orient at the time of the escape.

The camp's animals became an important feature of the community, and live animals like elephants were brought to galas and society events in nearby towns to help boost publicity and ticket sales. Special benefit days were held at the camp during which ticket sales were donated to various charities. In addition to functioning as a zoo and amusement center, the camp served as a holding center for exotic animals coming into New York from Buck's expeditions before being sent to other zoos and circuses.

In 1939, Buck temporarily took his camp to the New York World's Fair held in Flushing Meadows and opened a display entitled "Frank Buck's Jungleland." The fair, which was incredibly successful, reported over 200,000 admission tickets sold for Buck's exhibit in the first forty-seven days of operation. In a repeat of history, nine rhesus monkeys escaped from the exhibit but were recaptured a few hours later by World's Fair police.[19] Buck reopened the exhibit for the 1940 season as well.

Nassau Parks

Rides at the Massapequa Zoo in August 1964. *Courtesy of Edwin Sperling.*

Buck's suburban camp suffered during World War II, when the cost of gasoline made it difficult to bring customers and rationing affected the zoo's ability to acquire bananas for its monkeys, peanuts for its elephants and high-quality meat for its carnivorous animals. An article in *Newsday* in November 1942 even reported that some animals on display that were not lucrative eventually became meals for the big cats of the camp.[20] In 1943, the camp was no longer able to sustain itself, and Buck and Loveland shipped the animals to public and private zoos throughout the country. By February 1944, the now nineteen-acre property was being used for packing small-arms ammunition for the war effort. The Allen Recording Company took over four buildings of the former zoo in 1945, later becoming the Long Life Stamper Corporation, a record-making manufacturer.

In 1949, the Tryler Trading Corporation sold part of the Buck property to the Zoo-Site Realty Corporation. Frank Buck died in March 1950, at the age of sixty-six, due to lung cancer. Later that year, the building that had served as the Frank Buck Hotel reopened as the Sunrise Park Auction Outlet, selling foods, housewares and tools. The hotel building was the site of numerous stores and businesses until it was destroyed by fire in the 1960s.

Back in the 1950s, the Grimaldi family purchased the remaining property of Frank Buck's Jungle Camp and renamed it Sunrise Kiddie Land & Animal Farm. A year later, the site was renamed the "Massapequa Zoo and Kiddie Park." The six-acre zoo had a number of kiddie rides, such as a rollercoaster, boats, jet planes, a fire engine and a carousel. The Grimaldis advertised the zoo as being the former Frank Buck's Jungle Camp and still operated the famed Monkey Mountain. While some exotic animals were still on display, the zoo focused more on tame animals that could be fed by children or ridden like ponies. An advertisement in 1952 listed rides as nine cents each and noted that the zoo was open every day, offered refreshments and had free parking. The zoo had high attendance numbers and was incredibly successful with a television campaign in which it paid to have guest appearances on local kiddie shows filmed in New York City. Michael Grimaldi Jr. and his four brothers, Angelo, Anthony, John and George, ran the zoo until its closure in 1965. It was at this point that they sold the property to a developer to make additional parking space for White's of Massapequa, a shopping center next door. Although reluctant to close, the Grimaldis declared the real estate taxes too high for their now six-month-a-year operation. Local residents will recall the Massapequa Drive-In being located adjacent to the zoo from 1950 until 1968; before the zoo closed, visitors to the drive-in purchased their tickets near Monkey Mountain, so monkeys could be seen from the car windows.

There is still a Frank Buck zoo in operation in Gainesville, Texas—Buck's childhood hometown. There was a TV show on CBS in 1982–83 called *Bring 'Em Back Alive* that was based on the life of Frank Buck and starred Bruce Boxleitner.

The Sunrise Mall now occupies the site.

Gruberg Funland / Gruberg's Playland

Boardwalk, Long Beach • 1946–1980s • LOST

Long Beach, or the "City by the Sea," became known in the Greater New York area when the Long Beach Hotel was built in 1880. At the time, it was the largest seaside resort in the world at 1,100 feet in length with a high-end restaurant that could seat one thousand people. The hotel burned down in 1907, and Senator William J. Reynolds, active in developing numerous New

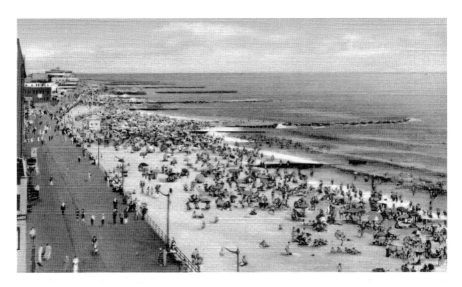

Crowds enjoying the surf, sand and boardwalk at Long Beach. *Author's collection.*

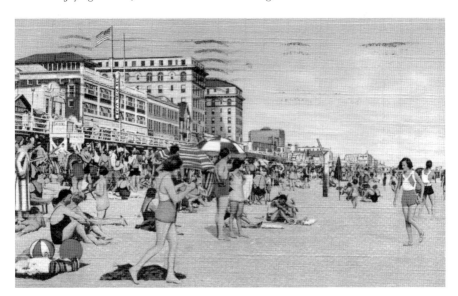

A postcard mailed to Pennsylvania from Long Beach in 1937 reads, "We were bathing here and it is just wonderful." *Author's collection.*

York City neighborhoods, as well as Dreamland in Coney Island, quickly set to work to make Long Beach the new destination seaside community. It was Reynolds who set out to create a boardwalk as the centerpiece of the newly redesigned city. He even brought two elephants from Dreamland to be

Historic Amusement Parks of Long Island

used in building the boardwalk to help garner publicity. Reynolds focused on bringing visitors to town via automobile and train rather than via the more obvious boat travel, and this provided easier accessibility for those coming from Manhattan. He strove to attract the elite and wealthy to Long Beach for dining, dancing and other luxuries. The town was officially incorporated in 1922, and it was during this time that the population here boomed. During Prohibition, Long Beach was a safe harbor for rumrunners, but by the '30s it was becoming home to families year round.

Max Gruberg had been in the carnival business since 1918, when he ran Max Gruberg's World Famous Shows along with his wife, Rose. In the 1940s, Gruberg brought his popular show to Long Beach, a surprising change since he usually operated in the Philadelphia area. He set up his carnival, which featured rides, concessions and shows, on a lot between Broadway and the boardwalk on Jackson Boulevard (today Edwards Boulevard, named after the late mayor Louis F. Edwards, who was murdered in 1939). He opened his kiddie park in Long Beach in 1946 on a spot where other kiddie rides had already been in operation. The park was located right against the boardwalk at the street level on a block-long piece of land owned by Gruberg. Features of

The Ferris wheel and other activities at the boardwalk level of the park. ©jeffreybkellner2014.

Nassau Parks

Funland included a carousel, Tilt-a-Whirl, a rocket, a fire engine, a streetcar, a wet boat ride, Sky Fighter, a miniature train, Loop-o-Plane, a mechanical elephant ride and a Roto-Whip. There were also food concessions and an arcade. Ticket prices ranged from nine cents up to twenty cents and could bring in $1,700 on a good Sunday. The park also sold season tickets to the park at $10 for 140 rides.

In 1948, Gruberg retired from the carnival business due to illness, but he decided to focus on his amusement parks, which were flourishing. Gruberg also opened a kiddie park in Flushing, and in 1948, he opened a ten-ride Kiddie Park in Miami, Florida. While running the Florida park, his second wife, Rae, operated the Long Beach park. The Long Beach park was expanded during this time to seventy-five thousand square feet, and new rides and games were added, including a Ferris wheel, Skooter, Caterpillar and a penny arcade. Early on, Gruberg only used female ride operators at both his Long Beach and Miami children's parks and had them dress in nurses' uniforms. Gruberg was quoted as saying that female operators proved more efficient in the handling of children.

In December 1950, Funland suffered from $9,000 worth of damages due to a storm. Three buildings suffered damages, but all the rides were still workable. A new carousel was installed in 1951, causing a boost to business and forcing Gruberg to place multiple advertisements in *Billboard* looking for independent refreshment vendors for the site. However, two years later, he was already forced to sell the carousel due to a decrease in his property size.

In 1952, Gruberg went back into the carnival business with his Atlas Bazaar and Ride Equipment Company Inc. This firm operated traveling carnivals with rides, performers and concessions. He took some of the less successful kiddie rides from the Long Beach park and used them for his mobile carnival. It was this same year that Gruberg completely renovated Funland, adding two new rides: a locomotive and a tank. He also added new equipment at his food stand and seven concession stands. By 1954, Gruberg continued to capitalize on the kiddieland craze, so he opened Playland in Trenton, New Jersey, and a twenty-acre kiddie park in Philadelphia. There were also reports of his running a park called Kiddie Wonderland in Brooklyn at Kings Highway and Forty-eighth Street. His wife, Rae, along with her sister, Celia, continued to run the Long Beach park while he moved between Long Beach and his Philadelphia park. By the mid-1950s, the kiddie park had been renamed Playland, and it was now a large park made up of two sections. There were rides for adults on the boardwalk and the kiddie park on street level below. The park was engrained into the community and even

Historic Amusement Parks of Long Island

Street-level view of the park's Ferris wheel. ©jeffreybkellner2014.

participated in annual charity events like "Orphans' Day," where thousands of children were treated to free rides. By this time, Playland's employees were all local teenage boys between the ages of twelve and sixteen.

While World War II had stunted the leisure time and spending habits of Long Islanders and people across the country, after the war ended, the desire for amusements began to bloom once more. New businesses like hot dog vendors and frozen custard stands and activities like shooting galleries and gambling began to appear along the boardwalk. An article featuring amusement parks across Long Island in 1972 listed the park as "Gruberg's Kiddyland."[21] At this point, it had thirty-two rides on four acres, open from April through September, with the kiddie rides closing at 11:00 p.m. on weekends and the adult rides on the boardwalk section closing at midnight. However, the 1970s saw a steep decline along the boardwalk area, including at the amusement park. Problems and disruptions were caused by local youths until a police drug crackdown cleaned the area, but by that point, many businesses and the kiddie park had already closed down. The 1980s brought a community push for urban renewal and led to big changes in the atmosphere of the area. A children's playground was eventually added along the boardwalk at Magnolia Boulevard.

Hurricane Sandy hit Long Beach on October 29, 2012, causing over $250 million worth of damage to the community and destroying the beloved boardwalk. After receiving federal and state grants, the boardwalk could be rebuilt and officially reopened on October 25, 2013. In the summer of 2014, a new miniature golf course opened adjacent to Riverside Boulevard. Barefoot Mini Golf joins the IFly Trapeze School and the Shoregasboard food truck court as part of a new amusement area developing along the boardwalk once again.

Kiddie Funland

Hempstead Turnpike, Farmingdale • ca. 1952–1954 • LOST

Little information appears for this small kiddie park. A newspaper advertisement first appeared in March 1952 for "Uncle Miltie's Kiddie Funland," located on Hempstead Turnpike in Farmingdale at the Long Island Railroad overpass. An ad in June of the same year indicated that the kiddie park had numerous rides and activities, including a merry-go-round, boats, fire engines, a miniature train, sport cars and live ponies. It also indicated that it had a restaurant or concession stand that served hot dogs, hamburgers and frozen custard. Rides were three for twenty-five cents with ticket books available. The park was listed as being open everyday until 9:00 p.m.

A new advertisement was published in May 1953 announcing the grand opening of Funland. Now, it was listed as a kiddie zoo with rides. The following month, an ad listed Funland as being open seven days a week. After this, no mention of the park can be found. The only photograph is an aerial view of the park where kiddie rides and the concession building—reading, "Kiddie Funland"—can clearly be seen.

The site later became Ed's Tropical Aquarium around 1958. This store was a chain with locations in Lynbrook, Manhasset and Roosevelt Field, as well as sites in Queens, Yonkers and New Jersey. The store remained at this site until at least 1989; it later became a Red Lobster restaurant, then a house of worship and today is a strip mall.

Historic Amusement Parks of Long Island

Kiddie Haven / Garden Amusements (McGinnis's)

Jericho Turnpike, Garden City Park/New Hyde Park • 1950–ca. 1988 • LOST

When Kiddie Haven opened in September 1950, it was just a four-ride park. Arthur Nelson, a ride manufacturer and operator, was a shrewd businessman who didn't spend any money on promotions or advertising during the first year of operation. His one full-time employee, Angelo Sorge, handled all aspects of running and maintaining the park for seventy-five dollars a week. Nelson chose the spot in Garden City Park because it was experiencing a boom in population and child-oriented businesses. It was located on a busy and well-traveled highway. There was also a Howard Johnson's located directly across Jericho Turnpike and an independently operated miniature golf course and a pony ride operator near the property.

Nelson owned Weld-Built Body Corporation of Brooklyn, which supplied kiddie rides and custom-built tow trucks for the New York

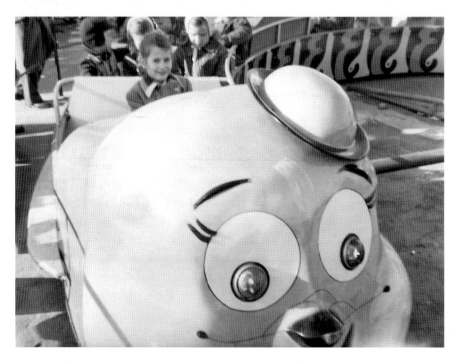

The caterpillar ride at "McGinnis's." *Courtesy of Marlene Platt Starr and Rhonda Platt Gavsie.*

Nassau Parks

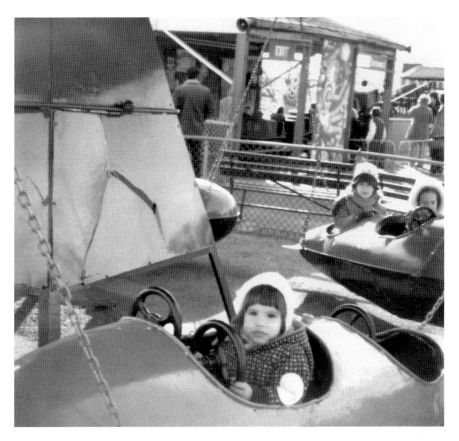

An airplane ride in 1975 at "McGinnis's." *Courtesy of Marlene Platt Starr and Rhonda Platt Gavsie.*

Police Department. Nelson's company manufactured all of the park's rides, which included a Ferris wheel, a locomotive, a water boat, a tank, a carousel and a Whip-type ride that he was trying to patent. The eight-engine locomotive ride was the most popular; each car bore the name of a Long Island town. Rides were nine cents each or three for a quarter, and ticket sales alone brought in around $1,000 on a good week. The park was paved in asphalt and fenced in, with benches lining the perimeter. The park was painted bright colors, with rides that had canvas tops, multicolored lights and cartoon figures. By 1951, the park had only six rides, a strategically planned number:

> *Nelson estimates that his customers average a half-hour visit. This amount of time, he feels, is enough to satisfy both the kids and their folks. And the*

Historic Amusement Parks of Long Island

crowds keep moving, another reason which is greatly responsible for the large repeat business Nelson parks get.[22]

In 1953, Nelson sold Kiddie Haven in its entirety to a group that would rename it Garden Playland Kiddie Park. Nelson used the experience he gained from operating the park in its three years to aid him with his ride-manufacturing firm, as the park served as a kind of showcase of his firm's work. At this point, Nelson established two other kiddie parks—one in Saddle River, New Jersey, and one in Grant's department store in Hempstead, which displayed three rides ten weeks a year in the store's toy department.

The park is usually referred to as "McGinnis's" by Long Islanders, as there was a restaurant of that name located on the site that opened shortly after the park in August 1953. McGinnis restaurants were popular in New York City during this time, with restaurants in Sheepshead Bay and Times Square. The eatery was famous for being the "Roast Beef King." The Pinsky family owned McGinnis's, as well as the kiddie park next door.

In the mid-1950s, Ted Platt purchased the park from the Pinskys, now known as Garden Amusement Park, although local advertisements for the park just

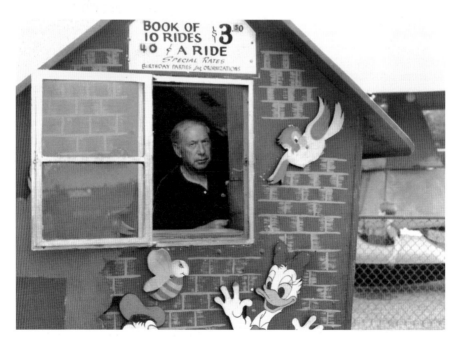

McGinnis's owner Ted Platt inside the brightly painted ticket booth. *Courtesy of Marlene Platt Starr and Rhonda Platt Gavsie.*

listed it as "Kiddie Park and Amusement Center." The Pinskys still ran the restaurant but didn't want the kiddie park any longer. Platt had previously run a jukebox and vending machine route and was friendly with the Pinsky family, as he would service the machines in the park's arcade. Platt dedicated himself to the site's maintenance and would constantly have the rides and signs repainted with unique characters to liven up the park. Like many of these local kiddie parks, many of the workers were teenagers from local high schools who stayed on for many years.

By 1972, the park had nine kiddie rides and a thirty-five-game arcade. It was open from April through September, seven days a week, but in the winter, it was open only on the weekends from 11:00 a.m. to 5:00 p.m. if the weather was good. The parking lot was able to accommodate four hundred cars. Platt was quoted as saying that business was better during the 1950s before the Long Island Expressway was built because there was more traffic on Jericho Turnpike.[23]

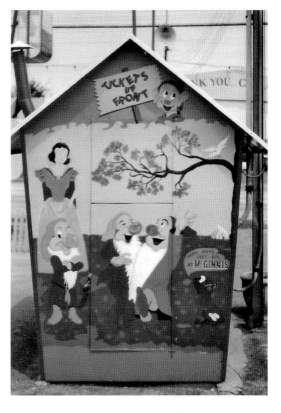

The back of the ticket booth colorfully painted with Disney characters. *Courtesy of Marlene Platt Starr and Rhonda Platt Gavsie.*

Large painted cutouts of various animals and characters—including a hippopotamus with opera glasses, wooden soldiers, clowns, sheep and other figures—decorated the chain-link fence surrounding the park. A roller coaster was eventually added.

In 1986, Platt sold the park and retired due to a heart condition. The park was purchased by Rocky Labelle, who worked at McGinnis's, and his nephew Joe. It closed shortly after.

Today, the Sperry office building and parking lot are located on the site.

Historic Amusement Parks of Long Island

Lollipop Farm

Route 25, Jericho Turnpike, Syosset • 1950–1967 • LOST

Located on the former Jackson Farm in Syosset, this petting zoo and kiddie park was operated by Harry and Alice Sweeny. Harry Sweeny, a landscape architect, worked as an aid to Robert Moses for the 1939 New York World's Fair and then became the assistant general director of the Bronx Zoo and designed its children's zoo in 1940. This 3-acre area within the 265-acre park allowed for children to have hands-on access to animals and their habitats. The Sweenys capitalized on the success of the Bronx children's zoo and created their own park in Syosset, which opened in June 1950—and they were not alone.

The Philadelphia Zoo was the first zoo in the United States, opening officially in 1874 after a fifteen-year delay caused by the American Civil War. It also boasted the first children's zoo in the western hemisphere, which opened in 1938 (the London Zoo was home to the world's first children's zoo, also in 1938). By the 1950s, we saw a boom in small-scale zoos opening near large cities as an attempt to educate urban and suburban children about nature. On May 8, 1959, a *New York Times* article discussing the development of these educational parks for children stated, "When city children are asked where

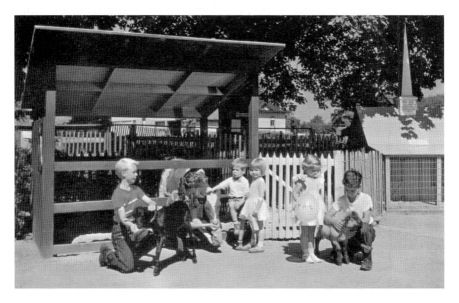

A postcard showing the children's zoo at Lollipop Farm in Syosset, where "feeding and petting tame barnyard animals are enjoyed by children of all ages." *Author's collection.*

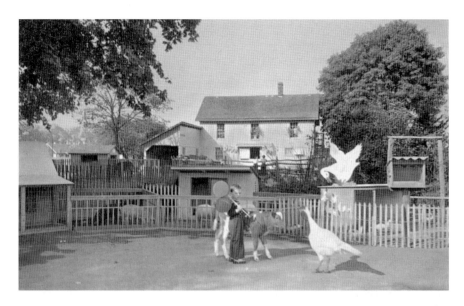

Lollipop Farm provided visitors with the opportunity to interact with and feed farm animals. *Collection of Gary Hammond.*

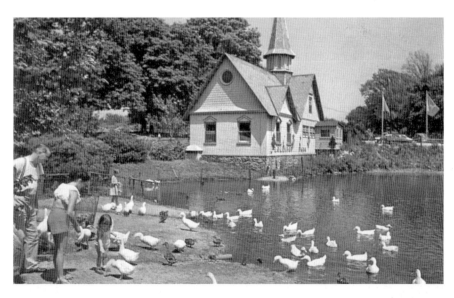

The property was previously the Jackson Farm. The building featured here was originally an icehouse and was used to house tropical birds when the property became Lollipop Farm. *Collection of Gary Hammond.*

Historic Amusement Parks of Long Island

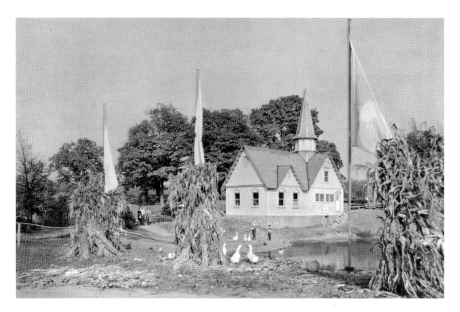

Lollipop Farm in autumn. This postcard, sent to Greenport in 1951, reads, "This is a picture of Lollipop Farm, we had lots of fun. Love Ruth Ann." *Author's collection.*

milk comes from, they often answer: 'From the milkman.'" The fear seemed to be that while children were familiar with the more exotic animals found at their city zoos, they had never actually seen a cow, chicken or other, more common animals. These zoos would house docile, domesticated, herbivorous animals. Sites dedicated to educating children about local animals soon began to pop up in the tri-state area—parks like Old MacDonald's Farm in Norwalk, Connecticut (1955–79); Storyland Village in Neptune, New Jersey (1956–62); and even special temporary animal exhibits like those found at the Children's Museum of Hartford, Connecticut (1927–present).

When Lollipop Farm first opened on Friday, June 16, 1950, it was advertised as "Long Island's Only Children's Zoo." Its four-acre property boasted baby animals, ponies, donkey cart rides, being open every day and providing lollipops for all visitors. The farm's namesake and mascot, Lollipop, was actually a goat that lived at the farm with her babies. Many animals were raised on the farm, but some were borrowed from nearby farms and then returned when they got too large. Although technically suburban, the area was still home to farms growing corn and potatoes, with new housing developments quickly sprouting. The Long Island Expressway didn't extend to Nassau County yet, and Syosset wouldn't have its own high school until 1956.

Nassau Parks

All animals could be fed and petted, including Pedro, a baby donkey; Daily, a Swiss calf; and Robbie, a piglet. Admission was twenty-five cents, with donkey cart and pony rides at ten cents. The park had a large pond for geese and ducks. There was also a building housing tropical birds that had previously served as an icehouse when the property was the Jackson Farm. One famous resident was Andy, a 150-pound Galapagos tortoise. The farm had six full-time workers, plus the owners and their two daughters. The parking lot could hold 250 cars, and the farm could accommodate 3,500 visitors. Quickly becoming a popular destination, the park greeted its 50,000th visitor in November—the visitor, a seven-year-old from Levittown—received a 23-pound live turkey. The farm

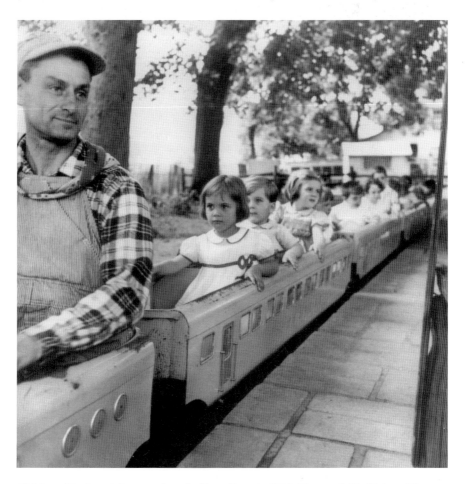

Children ride the miniature train at Lollipop Farm in 1952. *Photographed by Kathryn Abbe. Courtesy of the Society for the Preservation of Long Island Antiquities.*

welcomed over 120,000 visitors in its first year alone. Visitors became known as "Lollipoppers."

The most iconic aspect of the park was its kiddie train. Visitors may recall this gasoline-driven streamliner miniature train that children could ride around the park. The Rensselaer Miniature Train was the only ride at the park and was operated by an independent concessionaire: John Dryfuss.

Owner Alice Sweeny wrote a book introducing readers to the world that was Lollipop Farm. Written in 1950, it was whimsically illustrated in red, white and black by Kathleen Elgin. It was a guided tour through the park, stopping at the Billy Goats "Gruff House," the guinea pig penthouse, the pony track, the pink barn and the hilltop corral. Sweeny also wrote numerous booklets called *Stories from Lollipop Farms* that would feature specific residents like Lollipop, Bucky the rooster and Lalla the duck.

It became a special event when animals welcomed their litters. In February 1952, Willa the white rabbit welcomed nine baby bunnies. There were special animal attractions over time, like "Irish," the trick pony, which made an appearance on July 4 weekend in 1950, as well as performers like TV/radio personality and ventriloquist Shirley Dinsdale and her dummy, Judy Splinters. During the autumn months, Lollipop Farm would display corn, pumpkins and scarecrows for posed family photos. In the winter, baby animals would be moved to the indoor Mother Gooseland—"A gay, exciting fairyland to warm your heart these winter days." Santa Claus would even make an appearance around Christmas with his "Lollipop Tree."

In June 1951, a food bar was introduced called the Farm Fare, and prize poultry were displayed in the Bantam Barnyard. Children could even have their birthday parties at the farm; these included train rides, balloons, tours of the farm and cake for $1.25 per child. By December 1964, admission was listed as forty-five cents per person.

The New York community celebrated Lollipop Farm, and numerous articles were written in large newspapers like the *New York Times*, as well as more regional ones like *Newsday*. These articles mourned the loss of local farms in Nassau County but celebrated the park and the opportunity it gave local residents to enjoy farm life. By 1964, there seemed an overwhelming concern that children were becoming jaded by television, and papers praised Lollipop Farm as a positive family outing. The farm was even a spot for events held by the Fresh Air Fund to introduce children from poor urban communities to the suburbs. Harry Sweeny, along with his animals, appeared on numerous television shows, including *Howdy Doody* and *Arthur Godfrey*.

Nassau Parks

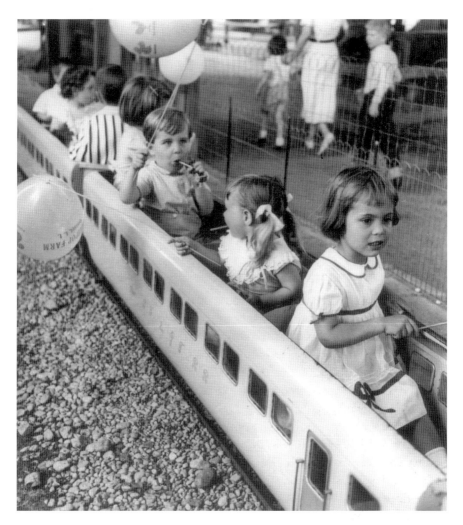

Children ride the miniature train at Lollipop Farm in 1952. *Photographed by Kathryn Abbe. Courtesy of the Society for the Preservation of Long Island Antiquities.*

The Sweeny family eventually decided to close, and the farm saw its last visitor in October 1966. The tropical birds and Andy the tortoise went to the Bronx Zoo, the lambs became part of a herd on Long Island, the calves and kids went to Suffolk dairy farms and the ponies went to private residences whose estates were large enough to house them. After finding homes for all its animals, Lollipop Farm officially closed in January 1967, with its owners retiring to Pennsylvania. In their last advertisement, they thanked the public for their sixteen years of operation and parted with a quote from Walt

Whitman's *Song of Myself.* In a final interview, the Sweenys estimated that Lollipop Farm saw over two million visitors in its sixteen years.[24]

A Mr. Stebbins purchased the miniature train ride when the farm closed. Stebbins lived on the North Shore and wanted to install it on his estate. Eventually, the Society for the Preservation of Long Island Antiquities obtained the train, and it was in storage at Lloyd Harbor for ten years. Later, the Greenlawn-Centerport Historical Association acquired it and organized a lengthy restoration process. Today, the train is fully functioning at the John Gardiner Farm in Greenlawn.

The former site of Lollipop Farm is now a DSW Designer Shoe Warehouse store.

Nunley's Amusement Park

Sunrise Highway, Baldwin • 1939–1995 • LOST

The lot William Nunley chose in Baldwin for his first Nassau County kiddie park was ideal due to its accessibility by public transportation. It was located directly across the street from a Long Island Railroad stop and on Sunrise Highway, a road that goes straight across the south shore of Long Island from Queens to Suffolk County. At first, the site was home to only a restaurant, the Dutch Mill, and a carousel pavilion. In 1947, additional rides were added, and it truly became an amusement park. A relatively desolate area when it first opened, by 1957, Freeport High School had been built on the lot just next door, and more businesses and restaurants were constantly being developed.

This small park featured numerous rides geared for young children. The first ride you would see upon entering the park was the Schiff wet boat ride. The boats were designed by B.A. Schiff & Associates, which also designed the park's Ferris wheel and roller coaster. The Ferris wheel was the tallest ride and would give you the best views of the entire park. At around twenty-five feet tall, the ride was made up of six multicolored cages that could hold two riders each. There was a Hampton Amusement Tubs-o-Fun ride, more commonly known as the teacups, with passenger-controlled spinning "tubs." It could hold twenty-four children or sixteen adults. There was a Hot Rod ride on a motorized track and an Allan Herschell Sky Fighter ride, which was extremely popular and could be found at amusement parks throughout

Each ride at Nunley's required a ticket. This ticket book was specifically for rides on the park's famous 1912 Stein and Goldstein carousel. *Courtesy of Dennis Ciccone Jr.*

This Allen Herschell Sky Fighter ride with Freeport High School's football field visible in the background. *Author's collection.*

Historic Amusement Parks of Long Island

The lead horse on the 1912 Stein and Goldstein carousel stands apart from the others due to its dramatic pose and elaborately carved cabbage roses. *Courtesy of John Lewandowski.*

the country. Some children absolutely loved the Hodges Hand Cars, but others hated them. The metal cars went around a winding track and were powered completely by the child turning the hand crank. The first roller coaster at Nunley's was designed by the Pinto brothers and was in operation at the park until some point after 1953, when the company went out of business. It was replaced with a new coaster that was from the Miami-based B.A. Schiff & Associates.

The majority of the amusements at Nunley's were rides geared for young children, but Nunley's wasn't just for little kids by any means. Freeport High School students were daily visitors to the park's restaurant for lunch to eat fries, hot dogs, burgers and pastrami sandwiches. They also came to play the newest games in the arcade, which was in the carousel pavilion. Visitors will recall Space Invaders, Asteroid, Pac Man and almost sixty others; numerous pinball machines; skeeball alleys; strength testers; and other coin-operated games.

The miniature golf course was added to the park in 1961 and allowed it to entertain a maturing audience as children became young adults. Visitors will remember that if you got a "hole-in-one" on the last hole, it would win you

There were over sixty games in the Nunley's arcade, including video games, pinball, skeeball and other coin-operated games like an automated fortuneteller. *Courtesy of John Lewandowski.*

a free game. The course had holes with names like Peter Rabbit, Horseshoe Curve and Double Mound Dog Leg.

The most iconic element of Nunley's Amusement Park was and always will be the beloved 1912 Stein and Goldstein carousel. The partnership of Solomon Stein and Harry Goldstein began in Brooklyn around 1905, when they were working at Mangels Carousel Works. They established their own business, called the Artistic Carousel Manufacturing Company, on Hopkins Street. Their horses are described as large and muscular with big heads and bared teeth. They attempted to soften the look of these warhorses by adding flowers and ribbons. Trademarks of their design are large buckles and the absence of forelocks—the part of a horse's mane that falls forward between the ears. Stein and Goldstein carousels are considered the Coney Island style, along with those by W.F. Mangels, Charles Looff, M.C. Illions and Charles Carmel. There are only four Stein and Goldstein carousels still operating throughout country, two of which are in New York: Nunley's and the carousel in Central Park.

The carousel began its life in Canarsie, Brooklyn—specifically, Golden City Park, where it was known as Murphy's Carousel. This amusement

The last hole at Nunley's Miniature Golf Course reads, "Bulls Eye Wins Free Game." The golf shack is to the left, and the carousel pavilion is in the background. *Courtesy of John Lewandowski.*

The way we remember Nunley's: view of the park looking south from Sunrise Highway. Visible are the restaurant, carousel pavilion and Schiff Ferris wheel. *Courtesy of Gary Monti.*

park was built in 1907 to rival those found in Coney Island. Located around Jamaica Bay, it was closer to Manhattan, with elevated trains and nearby trolley routes. The park featured dozens of rides, a bandstand,

shows and even a circus. The carousel remained in this location from 1912 until 1939, when the park closed. William Nunley then brought the carousel to its new home at what would become Nunley's Amusement Park in Baldwin.

One of the most beloved features of the Nunley's carousel was its music. The music for the carousel was provided by a band organ—specifically, a Wurl 153 w/MIDI. The carousel has both stationary horses and those that jump. While called a Stein and Goldstein carousel, the lion and three standing horses were by the Dentzel Company of Philadelphia, and there are ten jumping horses and three stationary horses that were carved by M.C. Illions and Sons of Coney Island.

The most memorable feature of the carousel was without a doubt its ring arm. Children could reach out and (hopefully) snatch a ring. If they were lucky enough to catch a brass ring, it got them a free ride. Being old enough, or at least tall enough, to finally reach the ring was a rite of passage for Nunley's patrons. To the chagrin of many, the ring arm was deactivated sometime in the 1980s due to liability concerns.

The carousel remained in Baldwin until the park closed in 1995, when the Lercari brothers (Lou, Steve and Jack), who had run the park since the 1950s, retired. Along with other rides and games from the park, it was scheduled to go up for public auction. However, at the last minute, Nassau County stepped in and said that it would purchase the carousel as a whole so that it could remain in the community instead of being broken up and shipped across the country. The carousel was in storage from 1995 to 2007, until funds could be raised for its restoration and a new home could be found for it. At that time, a fundraising program called "Pennies for Ponies" was started by a local nine-year-old girl named Rachel Obergh. Local schools raised the necessary funds for restoration, and eventually the carousel was shipped to Carousel Works in Ohio for the long process to begin.

Finally, after more than ten years, the Nunley's carousel returned to Long Island and to its new home in Museum Row in Garden City. After the closing of the park, threat of auction, local politics, community turmoil, fundraising and, finally, a massive restoration, the carousel was ready to open. A new carousel building was designed emulating the original. The carousel has been in this location since its grand reopening celebration in 2009.

Historic Amusement Parks of Long Island

Nunley's Happyland / Smiley's Happyland (Jolly Rogers)

Hempstead Turnpike, Bethpage • 1951–1978 • LOST

Nunley's Happyland, also known as Smiley's Happyland and sometimes referred to as Jolly Roger's—due to the restaurant adjacent to the property with that name—opened on October 12, 1951. It was located in Bethpage at the intersection of Hempstead Turnpike and Hicksville Road. William Nunley, amusement park entrepreneur and owner of multiple parks, including Nunley's in Baldwin, was the founder who invested $250,000 in his dream park. He designed the site to be larger than his previous parks; it was more than six and a half acres and was intended for year-round operation due to its twenty-thousand-square-foot indoor space. The main building, which housed the carousel and other rides, had large glass doors that could be removed during the warm months. These unique glass doors were from the French Pavilion at the 1939 New York World's Fair in Flushing Meadows, Queens. Built by architects Pierre Patout and Roger Expert, the lavish pavilion was designed using the huge windows to emphasize the view of the Lagoon of Nations.

Construction for Happyland began in 1950 but was delayed due to the Korean War, causing rising material costs and construction issues. After being heavily involved in the amusement park industry for years with his parks and carousel operations in Staten Island, Queens and Nassau County, Nunley was scrutinized by his peers in the industry for trying to develop an amusement park so far from a large city and public transportation. Nunley took little heed of these warnings and looked to the developing suburban environment, where families now traveled mostly by car. Nunley's assumptions were correct, and the park was incredibly successful in its so-called isolated location, but sadly, he wasn't able to celebrate his success. He passed away just six months before the park opened.

The park had similar rides to those at Nunley's park in Baldwin: Pinto Fire Engine, Herschell Sky Fighter, Hodges handcars, Schiff wet boats, antique cars, Tubs-o-Fun, a helicopter, an arcade with two hundred games and a miniature golf course. The indoor space was what truly made this park unique. While the outdoor rides were seasonal, oil heat provided comfort during the winter months so that indoor rides could still be enjoyed. In the warm months, fans helped cool down the interior, and the wall panels were removed to let in fresh air. Indoors held the Sky Fighter, a fire engine,

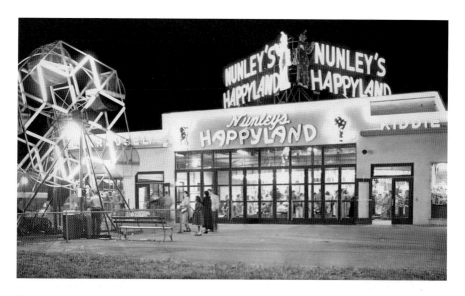

The Happyland building housing multiple rides, which allowed the park to operate year-round. *Courtesy of Dennis Ciccone Jr.*

The Happyland carousel building's removable glass doors came from the French Pavilion at the 1939 New York World's Fair and allowed the park to operate year round. *Author's collection.*

Pinto pony ride, boats, the carousel and arcade. These indoor rides had less weather damage and required less maintenance and painting.

Admission into the park was free, and ride tickets were ten cents each at the beginning. The original parking lot could hold three hundred cars,

but the need for expansion was quickly realized. Lou Lercari, future owner of Nunley's in Baldwin, was the manager of Happyland at the time. He lived in a house on the property that would eventually be torn down for expansion. The park, like so many kiddie parks, also had a carousel as its

Visitors check out a petting zoo at Happyland. Notice the sign for the Jolly Roger restaurant at right. *Courtesy of Dennis Ciccone Jr.*

main attraction. This carousel was a three-row Dentzel, made up of forty-eight horses and one bright pink rabbit. The music played by the carousel was unique, as it was provided by a rare Belgian calliope. At one point, this carousel was located at Rockaway Playland in Rockaway Beach and then at Nunley's Broad Channel Park. Originally, Happyland had a forty-four-horse carousel that was forty-eight feet wide. Miriam Nunley decided to relocate the larger carousel from Broad Channel to the Bethpage park because of the need for the larger-capacity ride at her more heavily trafficked park. The Schiff Ferris wheel was also a transplant; it had previously lived at Nunley's Rockaway Beach Park. There was also a German organ with hand-carved musicians that moved with the music's beat. In 1951, a kiddie roller coaster was added, as was a B.A. Schiff mini Ferris wheel that had originally been used at William Nunley's Rockaway Beach park.

In 1952, after Happyland was already seeing a great deal of success, Jolly Roger opened. This full-scale restaurant was located on the park's site but was run by concessionaire Max Lander and specialized in classic American fare. Its menu included hot dogs, hamburgers, fried chicken, clams, fish n' chips, hot sandwiches and ice cream. The restaurant was connected to the park via a glass-walled passage. Early advertisements didn't mention Jolly Roger and solely listed the site as Nunley's Happyland, while other ads listed the restaurant and only briefly mentioned the kiddie park. Both ads usually included a coupon for a free ride on the carousel. A clown seemed to serve as the park's mascot; he was referred to as "Happy" in 1951 and was later listed as the "Nunley Clown" in 1953. There were many shows, events, contests and performances by special guests, including "Bozo: The Capitol Clown." Around Christmas, a giant mechanical Santa would be on display that could talk and sing, and Santa himself would make appearances with gifts. In 1956, a Hot Rod ride was added, causing the kiddie train to be removed in order to accommodate the necessary six hundred feet of track.

Ads by the early 1960s began to list both Nunley's Bethpage and Baldwin locations, but the focus was on Happyland since it was the "all-weather amusement park" and was open year round. Nunley's in Baldwin was listed as "Nunley's Carousel and Arcade" rather than as a comparable kiddie park with rides.

Happyland held an important position in the community for many years but was not always a welcome sight. In 1966, the park became part of the agenda on an Oyster Bay town board meeting when a Bethpage resident complained about proposed additions to the park. Owners wanted to once again add a children's miniature railroad to the site, as well as pony carts, but

HISTORIC AMUSEMENT PARKS OF LONG ISLAND

Riding the three-row Dentzel carousel at Nunley's Happyland, circa 1970. *Courtesy of Nancy Radecker.*

eighteen community homeowners feared that the addition would lower their property values. In a statement through his attorney, the owner said "the train rides would be electric and noiseless…He added that, since purchasing Happyland, he had kept it clean, improved its appearance and employed special police to keep undesirables away."[25] Ultimately, the request was approved; an advertisement for the park published in October 1967 listed the new "Iron Horse," described as "the railroad ride with the authentic western twang. Get on board for a rootin'-tootin' choo-choo ride. Great for kids & adults of all ages."

Advertisements asked: "Don't you wish someone would take you to Smiley's this week…your best girl, your parent…or a friend…or come on over yourself, and have a ball."[26]

In the 1970s, adjacent to the park, a batting range was added, as was an eighteen-hole miniature golf course—features that were quickly becoming popular in the area.

The popular Jolly Rogers restaurant changed names in 1974 and became Robin Hood. The restaurant closed in 1976, after two short years, and the amusement park followed two years after that. The park's closure was blamed on "rising operating costs, a declining number of children, more sophisticated amusement parks elsewhere and the fast-food restaurants that in recent

years have drawn customers away from the Jolly Roger."[27] On November 21, 1978, a public auction was held for the 1906 Dentzel carousel, eleven park rides, the mini golf course, arcade games and miscellaneous restaurant and park pieces. All the pieces were sold, with carousel horses going for anywhere from $600 to $5,000. Twenty of the horses were purchased by Knottsberry Farm in Buena Park, California, to be added to the carousel at the amusement park there.

Today, the site is a strip mall.

Playland Park

South Grove Street, Freeport • 1924–1931 • LOST

Freeport is an incorporated village within the Town of Hempstead, Nassau County. Founded about 1659, it was originally named after its founder, Edward Raynor, a cattle herder. The village of Raynor South became known as a "free port," likely due to the free dock space provided to small boats by the local baymen. In 1853, residents, who were mainly fisherman or farmers, voted to have the town officially renamed Freeport. At the turn of the twentieth century, when the amusement park boom was taking place throughout America, Freeport was part of the action as a bustling resort town attracting visitors with its beaches, hotels and world-renowned oysters.

Freeport eventually became an ideal location for year-round residence. By the 1920s and 1930s, the population had grown due to the establishment of new schools, religious institutions, a library, a village hall and a post office. Freeport was also a hotspot for rumrunners—those who were involved in the illegal transportation of alcohol during Prohibition. This included many restaurants, some of which served as speakeasies during this time. Freeport quickly developed a booming recreation business with institutions such as the South Shore Yacht Club, the Sigmond Opera House and various vaudeville theaters, movie houses, golf courses and public parks.

With the village's vast waterfront property and enticing leisure spots, it was only a matter of time before a large-scale amusement park was built. Playland Park, the so-called Coney Island of Long Island, opened in 1924. It was located on nine acres southeast of Front and South Grove Streets. South Grove Street is known as Guy Lombardo Avenue today. The Woodcleft Basin and the Hudson Canal surrounded the park. The park featured a

Historic Amusement Parks of Long Island

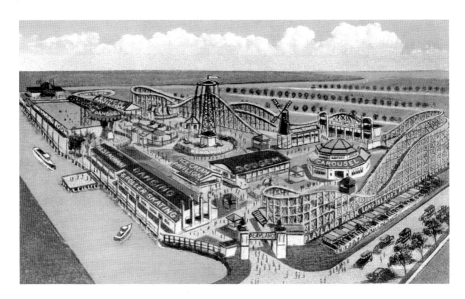

This postcard depicts Playland and its surrounding flatlands. The water to the east of the park is the Hudson Canal, and the Woodcleft Basin is to the north. *Courtesy of Freeport Historical Society.*

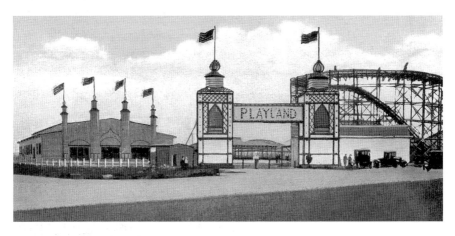

A postcard showing the elaborate entrance gate of this "small-scale Coney Island." The building to the left was used for dancing and roller-skating. *Courtesy of Freeport Historical Society.*

large roller coaster, a swimming pool, a Whip ride, swings and a pony track. It also had various buildings containing rides and other activities, including a carousel; dodgem, or bumper cars; roller-skating; and dancing. There were also those containing concessions like an ice cream pavilion, a lunch pavilion and a restaurant. Since the park sat right on the water, there were

also opportunities for swimming, boating and other seaside enjoyments. The park had it all. Much like the sign said out front, it truly was "Long Island's Amusement Centre."

Fire led to the demise of many amusement parks of the era, and it seemed as though Playland was destined to meet the same ending. Shortly before Playland first opened, on May 12, 1923, at 3:00 a.m., a fire destroyed the Kegel bathing pavilion and caused an estimated $10,000 worth of damage. A *New York Times* article on May 13, the day after the fire, reported, "The pavilion adjoined 'Playland Park,' a new amusement venture, but the park was not damaged by the blast." Playland was threatened by fire before it had even formally opened, but planning continued. Charters from the early 1920s show the Playland Whip listed as "amusement devices" for $20,000, as well as one for the Playland Natatorium for $50,000. A natatorium is a building that houses a swimming pool.

It was in 1929 that things took a turn for Playland. The Great Depression had begun, and its effects would quickly be felt around the world. The amusement park industry was hit especially hard during this time, as people had little money to live let alone for unnecessary frivolities. In August 1929, Jones Beach State Park officially opened. This park was the first major public project by Robert Moses, the famed president of the Long Island State Park Commission. This new park lured potential visitors away from Playland with its new facilities and parkway.

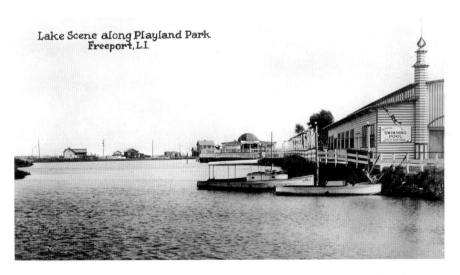

Located right on the water, boats could dock along its shore. The sign pictured reads, "Playland Swimming Pool end of boardwalk." *Courtesy of Freeport Historical Society.*

Unfortunately, like so many other amusement parks of the era, Playland Park did indeed succumb to fire in 1931. In a turn of events that can be described only as ironic, on June 28, 1931, Freeport's entire fire department was on location at a house at Maple Street and Mill Road pretending to put out a fire for a film entitled *The Story of Freeport*.[28] The film's star, Mitzi Hallosy, was poised in a synthetic cloud of smoke in an upper window, about to "jump" to the safety of the firemen's net below, when the actual firehouse alarm went off. The firemen raced the half mile to Playland Park but found that the fire was beyond their control. The park's pavilion was destroyed, and it was later discovered that the motion picture company filming *The Story of Freeport* had been storing equipment inside—a loss of $100,000. Fire officials found that the fire was caused by a short circuit.

A few years later, the Freeport Yacht Club was founded on the same site. The clubhouse was located inside of a large ship that was once a submarine tender for the navy.

Roadside Rest Kiddieland / Kiddieland Park / Jazzbo-Land

Long Beach Road, Oceanside • 1953–1976 • LOST

Long Beach Road originates in Hempstead and then cuts through Baldwin, Oceanside and Island Park and ultimately serves as the main thoroughfare into the "City by the Sea," otherwise known as Long Beach. As such, over the years many restaurants, shops and other sites have developed along this widely traveled road in order to capitalize on the traffic heading to and from the beach. Some of the popular restaurants on Long Beach Road include Pete's Stable, Mammy's Chicken Farm, Bigelow's, Peter's Clam Bar, Janowski's Hamburgers, Johnny Russell's and Pasettis.

One such site, the Roadside Rest, opened in 1921 and was run by Leon Shor and Murray Hadfield. Originally just a fruit and vegetable stand, the Roadside Rest sold fresh produce, sandwiches, frankfurters and cold drinks. By the 1930s, it had evolved into a massive restaurant that could seat over four thousand. The Rest had an open-air pavilion where diners could listen and dance to live music. By 1953, next door to the restaurant was an area called Roadside Rest Kiddieland run by Bob and Bernie Finkel. This small-scale amusement park featured a stage and numerous rides, including a

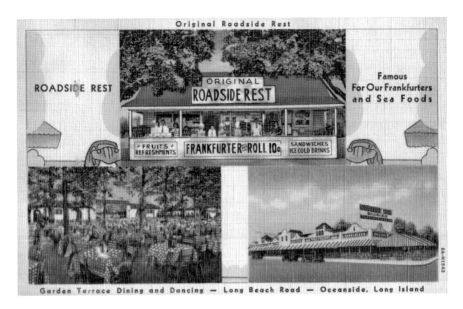

A color postcard showing the evolution of the Roadside Rest from a fruit stand to an open-air restaurant that could seat thousands. *Author's collection.*

seventy-horse Mangels carousel, circa 1914; a train; a circle swing; Roto-Whip; a water boat; and a mini Ferris wheel. There was even a temporary exhibition called the Joyland Zoo added in 1953. The zoo included monkeys, lambs and other animals. The park was paved and fenced in.

The Kiddieland on the restaurant grounds was meant to attract entire families with its heated patio and sizeable free parking. On Saturday afternoons, the Roadside Rest would host free kiddie shows at its so-called Kiddie Kabaret, which featured performers of TV, radio and theater. It even hosted children's birthday parties, which in 1959 included a gala birthday luncheon and a gift for each child at a price of $1.50. Advertisements from this time boast, "With no dishes, no mess, no bother for mother and lots of fun for the youngsters." The park was successful, seeing from $650 to $700 per day in ticket sales. The weather played an important role in the success of the park, but not in the typical way. Warm, clear days would find families visiting Long Beach, and it was the cloudy days on which the kiddie park was the ideal choice. However, many families also tended to visit the park in the early evening on the way home from the beach.

After World War II, Oceanside, much like the rest of Long Island, saw a surge in residents looking to move from the city into the suburbs. In 1956, Murray Handwerker, son of Nathan Handwerker, founder of Nathan's

Famous of Coney Island, purchased the restaurant and the kiddieland with his wife. Handwerker strove to entertain the crowds, so he held special activities each day of the week, with a focus on kids and families on the weekends. A listing in the *New York Times* for Saturday, October 12, 1957, reads, "2 P.M.: Art Arnold, television puppeteer, will entertain children at Roadside Rest, Long Beach Road, Oceanside, L.I. The hour-long program is free." He officially reopened the site as Nathan's Roadside Rest on June 4, 1959, when his father bought him out. The site officially became the second Nathan's in what would become a worldwide chain. Opening day boasted free hot dogs, ice cream and rides at Kiddieland Park. The Nathan's logo now listed both the Coney Island site and the Roadside Rest location.

In 1961, Oceanside resident Edmund A. Tester Sr. took over Kiddieland. Tester was known in town as "Jazzbo," a circus clown who made annual appearances in the Memorial Day parade and other community events. Jazzbo would come to events in his car, the JAZZMOBILE, a Model A Ford from 1930.

Over time, the name Roadside Rest was phased out, and the site was listed as just Nathan's Famous. The amusement park was now referred to as Oceanside Kiddieland at Nathan's Famous, with a lion mascot nicknamed "Fluffy." Nathan's became an integral part of the community, even hosting an eight-week-long music festival in 1964:

> *The Oceanside Music Festival this year is extending its season from the six weeks for which the program ran for the last two years to eight weeks. The concerts are given in a tent with a seating capacity of 1,200, which encloses the stage and outdoor gardens adjoining a place once known as the Roadside Rest where well-known swing bands played in the nineteen-thirties and nineteen-forties. It is now a branch of Nathan's, the Coney Island hot dog vender, which sponsors the concerts as part of the Oceanside School District Recreation Program.*[29]

The so-called Jazzbo-Land closed in 1965, but the park remained open. Nathan's kept trying to entertain families with weekly puppet shows at its Nathan's Famous Family Playhouse. By July 1966, advertisements had begun to appear in the local newspapers independently advertising Oceanside Kiddieland. The park was listed in local advertisements that encouraged residents to vote, alongside numerous Long Island businesses such as Metropolitan Savings Bank, Roosevelt Raceway, Tillie's Fashions and Wittmann Rabbitry.

Murray Handwerker sold the entire property in 1976. The original building was demolished in June of that year.

Nathan's Famous was located on the property until 2014, and the building was similar to others in the franchise. Recent press indicates that Nathan's will soon be relocating to a new lot a few miles north of the original location on Long Beach Road. Hopefully, Long Islanders new and old will still be able to experience a taste of the past.

Spaceland

Old Country Road, Carle Place • 1958–ca. 1960 • LOST

On June 21, 1958, a converted airplane hanger approximately one hundred by sixty feet, directly across from Roosevelt Field, officially became an amusement center called Spaceland. Owners Lester Tobin and Lionel "Mike" Michaels established the educational theme park that displayed models of solar systems and satellites and even housed a seventy-four-foot rocket. The focus of the park was the world of the future, as well as the evolution of flight. An article in *Newsday* from 1958 shortly before the park opened said, "There will be displays of orbital navigation by rocket ships, apparatus to illustrate jet propulsion and the manufacture of oxygen such as will be needed by humans who hope to colonize the moon or other planets and sky-ceiling depicting the zodiac in lights."[30]

The rocket, nicknamed "The Astronaut" and equipped with controls and a large screen, acted as a flight simulator and could hold one hundred riders at a time. Riders experienced film clips, vibrations and sound effects during their flight simulations. Visitors could explore a fictitious world called "Planet Vulcan," as well as participate in a "Martian Hunt." This room was located on the building's second floor and was designed by sculptor Jack Giasullo of Leo Russel Studios. Inside were lunar fountains, galactic monsters, space gas and actors serving as space guides. Spaceland boasted indoor and outdoor rides, including a helicopter, the Little Dipper, a boat ride, Jolly Caterpillar and Sky Fighter. All rides were Allen Herschell models. There was also an arcade, a photo booth with space creatures, concessions and shooting galleries. Each child received a free Spaceland Ranger badge.

Spaceland employed numerous costumed staff members who were stationed around the park. In an article in *Billboard* on June 30, 1958,

HISTORIC AMUSEMENT PARKS OF LONG ISLAND

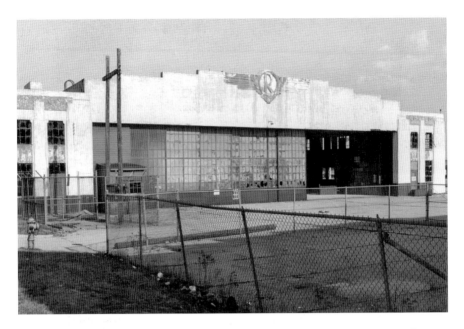

The abandoned Roosevelt Field hanger in the 1950s that would become the home of Spaceland Park. *From the Village of Garden City, New York Archives Collection.*

following the park's opening, the performances are described: "The stage is used for a regular Western posse routine, so common at frontier towns, different only in the futuristic setting. In this case, kids trail the space pirate, not the stagecoach bandit."[31] There were daily performances, including those by "Captain Comet and his Space Ranger Show." Early ads listed "Entertainment Staged and Directed by Al Hodges of Captain Video Fame." Special guests included Fred Scott, host of *Bugs Bunny Presents*.

Unlike other kiddie parks around Long Island, the center was entirely indoors, so it could operate in all weather. Open year round, admission was fifty cents for children and seventy-five cents for adults on opening day. Four days later, the price had dropped to twenty and thirty-five cents, respectively. By July 9, advertisements showed admission for all visitors at twenty cents, and by late October, admission was free. In November, the park was open only on Saturdays and Sundays. Spaceland had a strong support staff dedicated to increasing ticket sales, including two staff members handling advertising, as well as a publicist. In an interesting ad campaign, visitors could receive discounts on ride tickets by buying products with Associated Foodstore brand labels. In 1959, a flight room, designed by two Long Island teachers, was added that showed the history of the rocket and missile age with models.

Nassau Parks

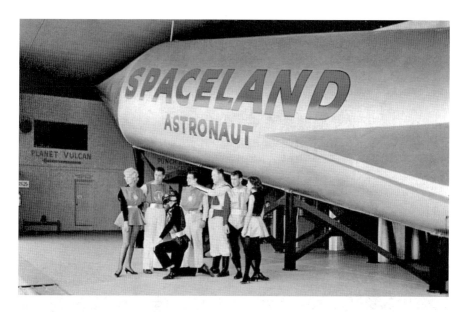

A postcard of Spaceland Park featuring Captain Comet, Lieutenant Lunar and other members of the "crew" posed in front of "The Astronaut" rocket and flight simulator. *From the Village of Garden City, New York Archives Collection.*

Spaceland continued aggressively campaigning and kept adding new rides and monetary prizes, but its biggest boost was from a TV spot by the park owner. Lester Tobin made multiple appearances as a contestant on the quiz show *Name That Tune*, winning over $10,000. The mention of his business to the twenty-eight million viewers significantly increased attendance numbers. On May 18, 1958, *Billboard* documented it as "a five-fold increase in weekend business is the reported result of a nationwide TV plug for Spaceland."[32]

Unfortunately, Spaceland was tangled in a scandal involving stock fraud in July 1959. According to the state's attorney general at the time, Louis J. Lefkowitz, shareholders of Spaceland (among other businesses) were guilty of fraudulent promotion of its stock. It was claimed that there were multiple sites around the country where other Spacelands were in construction or about to be constructed. It was also said that a TV personality, Captain Video (aka Al Hodge), would play a role in these parks. The vice-president of Spaceland, Inc., Lester Tobin, claimed that the company was unaware of these claims.

Spaceland closed soon after, and the hanger became the Michael Myerberg film studio. Films like *Santa Claus Conquers the Martians*, *The World of Henry Orient* and the TV movie *A Carol for Another Christmas*—all released

Historic Amusement Parks of Long Island

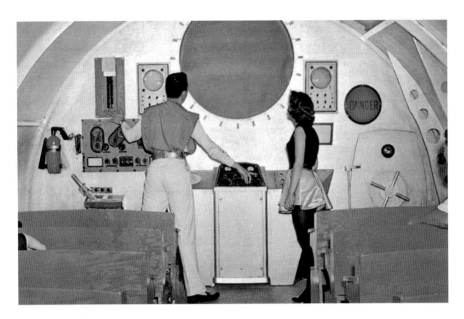

A view from inside Spaceland's rocket ship, the Astronaut. The postcard boasts that visitors will "see meteors, planets, stars and space stations" while on board. *Author's collection.*

in 1964—were shot there. Myerberg later backed a nightclub being opened in the building that utilized the remaining space-themed décor. The club caught the attention of pop artist Andy Warhol and filmmaker Paul Morrissey, who were looking for a venue where they could incorporate multimedia design and showcase their band, the Velvet Underground. Myerberg was intimidated by Warhol and his posse and chose a more crowd-friendly personality to represent the club.

Murray the K, or Murray Kaufman (1922–1982), was a popular disc jockey from the 1950s through the 1970s who commonly referred to himself as the "fifth Beatle." Capitalizing on his radio popularity at the time, he became the figurehead for Murray the K's World, one of the first nightclubs to integrate multimedia into its design. Images and film clips were projected while recorded music played in the club. With designs by USCO, a multimedia art collective popular at the time, the club used strobes, film, light projections and electronic programming to create its psychedelic performances. The airplane hanger that once held Spaceland would now hold around 2,500 club-goers. Big rock acts of the time were said to have played at the club, including the Isley Brothers, Gandalf and Mitch Ryder, and opening night featured the Young Rascals and the Hollies. Murry the

K's World was described in a review in an April 1966 issue of the *New Yorker*: "[It] resembled a combination roller-skating rink and adobe pizza parlor."³³ After a conflict between Kaufman and Myerberg, the club became known as The World. The technology and design used in the space was so innovative that the club was actually featured on the front page of the May 27, 1966 issue of *Life* magazine.

Eventually, the site was demolished and became home to various stores such as Levitz Furniture.

Worth Mentioning

These are parks that I came across in my research but couldn't find much information on—do you remember?

THE GARDENERS' VILLAGE

Hempstead Turnpike and Cherry Valley Avenue, West Hempstead • 1950s

Kiddie Zoo

GRANT'S DEPARTMENT STORE

Hempstead • Holiday Season 1950s

Basement toy section,
Locomotive, tank and Whip

MID-ISLAND PLAZA

Broadway, Hicksville • 1960s

Gagnon's Kiddie Park

ROOSEVELT FIELD

Meadowbrook Pkwy, Garden City • Late 1950s–1960s

Kiddieland

Chapter 4
SUFFOLK PARKS

Suffolk County makes up the easternmost area of Long Island and is the largest of its four counties. While some towns and villages are densely populated, there is still a great deal of active farmland. This area was home to many amusement parks, particularly those with specific themes like the Wild West and fairy tales.

Bay Shore Amusement Park

Sunrise Highway, Bay Shore • 1955 • LOST

This amusement park was located on Sunrise Highway and the corner of Brentwood Road. Marketed as "One of the Largest on Long Island," the park was right next door to the Bay Shore Farmers' Market and the Bay Shore Sunrise Drive-In Theatre. An advertisement in May 1956 announced the grand reopening of the park with free admission. The park had a number of kiddie rides, including a carousel, a Ferris wheel, tanks, boats, fire engines, Sky Rocket, a train and Moon Rocket. The park also was marketed to teenagers and adults with a large Ferris wheel, a roller coaster, Spitfire, Whirl-a-Round and an eighty-foot Hi-Ball.

The park was open seven days a week and catered to birthday parties and large groups; it also had a picnic area with benches and tables. Free

balloons were even distributed to children. It had a parking lot that could accommodate thousands of cars. The farmers' market publicized itself as the "market with the carnival atmosphere."

Dodge City

Sunrise Highway, Patchogue • 1957–ca. 1962 • LOST

In the late 1950s, the Wild West was a popular topic for television, film and literature, and many entrepreneurs tried to capitalize on the craze. Dodge City was a western-themed kiddie park that opened on June 29, 1957, on Sunrise Highway and Waverly Avenue in Patchogue. Set up like a miniature town, there was a bank, saloon, dry goods store, barbershop, silversmith, post office and jail, all of which visitors could walk through. Western-style clothing like cowboy hats and holsters could be purchased, as could Native American crafts, silver jewelry and trinkets made of wrought iron. The saloon served hamburgers, hot dogs, soda and other refreshments.

The lure of the park were the dramatic events that would take place every day, such as Jesse James and his gang's hold-up of the Dodge City bank, which included a shootout, a getaway in a stagecoach and a trial for the

A view of Dodge City's miniature railroad and its many shops. The building in the background reads, "Tonsorial Parlor." Tonsorial refers to a barber or hairdresser. *Collection of Gary Hammond.*

criminals in which visitors could serve as witnesses. There was also a rodeo with bulldogging, roping and rescue racing. Cowboys and cowgirls would ride trick horses with gun-twirling acts and other trained animals. Displays of archery would be performed, as would Native American dances. Visitors could ride the stagecoach as well as ponies.

Opening day in 1957 saw television celebrities such as Joe Bolton, known as "Officer Joe" and the host of *The Clubhouse Gang*. Local businesses helped with publicity, including Cowboy Al's Huntington Outlet, a bath and other appliance stores. Advertisements shortly before Dodge City's grand opening indicated that Cowboy Al himself, as well as his two daughters, would be performing trick riding and roping on opening day. Admission was thirty-five cents for children and sixty cents for adults, and there was a five-thousand-car parking lot. The park was open weekdays from 11:00 a.m. until 5:30 p.m. and weekends from 11:00 a.m. until 7:00 p.m.

By 1958, admission prices had increased to fifty cents for children and ninety cents for adults. However, there were now more special guests each week, like Clarabell the clown, sidekick to the popular Howdy Doody. Dodge City also hosted numerous western stars like Joe Phillips; his wonder horse, Smoky; and his wonder dogs, Sandy and Shep, all of which appeared in several television shows, like *Captain Kangaroo*, during the 1950s. There was also Lost John (Crethers) and his trained mule, Mickey Mouse, and rope and whip artists Bud and Rose Carlell, popular around the country, who performed with Gene Audrey at his Madison Square Garden rodeo in 1948.

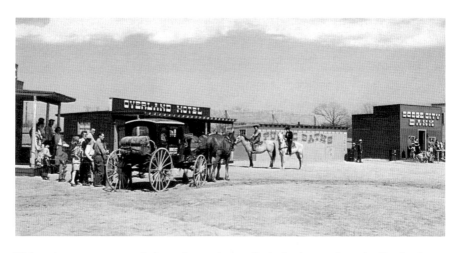

Visitors inspect a stagecoach drawn by two horses. In the background are the Overland Hotel, the Public Baths and the Dodge City Bank. *Collection of Gary Hammond.*

Historic Amusement Parks of Long Island

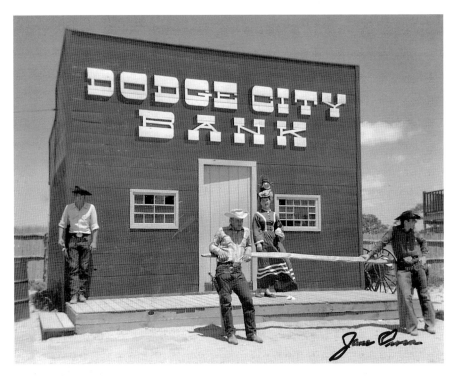

Actors, including local resident Jane Owen playing the notorious outlaw Bell Star, pose in front of the Dodge City Bank before they staged a robbery there. *Courtesy of the Eaton family.*

Another star was Fay Kirkwood, a professional rodeo woman who staged a rare all-girl rodeo in Texas in 1942 since a large number of cowboys had been drafted into World War II and regular rodeos were cancelled.

In 1960, the park underwent plans for expansion. Operations were now being run by realtor Roy Feinberg and boardwalk operator Irwin Wohlman, both of Long Beach, in collaboration with Barney and Tony Marino. According to an article in *Billboard* that March, the park would now offer more rides and concessions, as well as additional television star appearances. Admission had increased to seventy-five cents for both children and adults, but all received "free gifts," according to local advertisements. Guests were encouraged to "bring your camera," and gift certificates were even given to adults toward developing their black-and-white film. At this point, the miniature railroad was removed to make way for the coming rides.

The theme park closed at some point in the 1960s. Some of the buildings from the park were sold to nearby farms or were relocated to Mastic Beach and Center Moriches.

Suffolk Parks

Fairyland at Harvey's

Jericho Turnpike, Huntington • ca. 1960–1964 • LOST

After opening and maintaining the successful Fairyland, aka Buddy's Fairyland, in Brooklyn, owners Irving Miller and Leo Davis decided to open a second location in Irving's hometown. The new Fairyland was located in the town of Huntington, specifically Elwood, at Jericho Turnpike and Elwood Road. A smaller version of the Brooklyn park, Fairyland at Harvey's had a Ferris wheel, a carousel, a train, an arcade and a miniature golf course.

Tragedy struck this kiddie park on June 29, 1964, when a two-and-a-half-year-old girl fell from the Ferris wheel and was fatally injured. Deborah Shaw of Commack was riding the Ferris wheel with her parents when their seat flipped over at the top of the ride. The Ferris wheel cars were enclosed with mesh and covered with a canvas roof. When the car flipped, all three passengers broke through the canvas. The parents fell to the empty seats below, but the child fell sixty feet to the ground. The young parents—the mother was five months pregnant—were seriously injured but survived, as did the unborn child. The couple filed a $2 million suit against the amusement park for damages and pain and suffering. The couple claimed that the Ferris wheel door was not properly secured and that a fifteen-year-old boy was operating the ride—a violation of the state labor law that mandated that the minimum age for such work was eighteen.

The Ferris wheel had previously passed all inspections, and tests done after the accident saw that it was in perfect working order. However, this wasn't the first time that the ride had caused an injury. In April of the same year, a nine-year-old was injured when the iron door of one of the cars was torn off, but repairs had been made. Numerous articles were written in *Newsday*, as well as the *New York Times*, covering the tragic story.[34]

The owners were so distraught by the child's death that the park closed soon after. Today, the site is a gas station, and up until a few years ago, there was still a sign behind the station mentioning the park.

Historic Amusement Parks of Long Island

Fairytown, USA

Jericho Turnpike, Middle Island • 1955–1963 • LOST

Fairytown was marketed as being "where fairy tales come to life." This storybook-inspired village opened on May 28, 1955, and made classic children's stories a reality in its twenty-eight-acre park across from Artists Lake. Visitors could walk through life-sized reproductions of places like the Planet Mars and Mother Goose Village. They also had the opportunity to meet and interact with characters like Humpty Dumpty, Little Red Riding Hood, Peter Pumpkin Eater and the Old Woman Who Lived in a Shoe. Owned by Nicholas Tirlizzese, who resided on the property, the park was also maintained by four family members and three outside helpers.

Tirlizzese began an intensive marketing campaign to help promote the park and bring in large groups through local radio and newspapers. He successfully brought in numerous school visits due to calls and mailing brochures and pictures of the park. Although the park was situated on a well-traveled road, the area was relatively unpopulated at the time of its opening. The owners hoped that, like at other kiddie parks throughout the island, expanding suburban populations would eventually bring potential business.

"The Old Woman Who Lived in a Shoe" exhibit in Mother Goose Village. *Collection of Gary Hammond.*

Suffolk Parks

Visitors in July 1962 pose with spaceships and a rocket from the Planet Mars section of the park in the background. *Collection of Gary Hammond.*

Fairytown had its own petting zoo, where children could feed the animals, including deer, llamas, red foxes and domestic and barnyard animals. In 1955, Miriam Nunley, who owned the previously discussed kiddie parks in Rockaway, Broad Channel, Baldwin and Bethpage, began operating rides at Fairytown on a concession basis. She brought a Herschell carousel, a Schiff wet boat ride, Pinto fire engines, Hodges handcars and a Mangels dry boat ride. These rides were brought from the closed Nunley's location on Central Avenue in Yonkers. This location was forced to close due to the building of the New York Thruway.

There were also two food concession buildings operated by the Walter Reade Theaters chain from New Jersey. They filled the park with vending machines selling drinks and even cigarettes. The Reade chain operated concessions in theaters, restaurants, beach clubs, racetracks and drive-ins in New York, New Jersey and California. They also ran concessions at the comparable kiddie park Storyland Village in Neptune, New Jersey. Fairyland boasted picnic areas next to "Fairytown Lake," a pond on the property usually full of ducks. The park was open from 9:30 a.m. until dusk, with free parking and an admission price of fifty cents. A seasonal park since it was entirely outside, it would open for weekends beginning in April, and then by the end of May, it would be open daily.

A postcard of a spaceship exhibit with aliens in the Planet Mars section of Fairytown. Children could walk inside and investigate many of the displays at the park. *Author's collection.*

"The Giant and the Hen" exhibit at Fairytown referencing the nursery rhyme of Jack and the Beanstalk. *Author's collection.*

As visitors walked through the village, they would come across storybook characters they knew dressed in costumes like the Old Woman Who Lived in a Shoe in her eighteen-foot-tall shoe-shaped house that children could actually go inside. Rough handling by young visitors

required constant maintenance and replacement of various character figurines. There were twelve fairy tale structures throughout the park. Additional exhibits were Jack and the Beanstalk, Little Miss Muffet, Little Boy Blue, Baa-Baa Black Sheep, Jack and Jill, a little red schoolhouse and the Three Little Pigs with each of their houses. Visitors could even ride on a covered wagon through the village.

Special attractions and events were scheduled regularly. An advertisement from July 1960 claimed that visitors could see a "Seminole Indian Fight Ferocious Alligator" every hour from 11:00 a.m. until 7:00 p.m. Parents were encouraged to bring their cameras to document their children's tours through the park.

Although the park remained open until at least 1963, advertisements in *Billboard* in 1958 indicate that the entire park was up for sale. There is no information about whether the park changed ownership during this time. After Fairytown closed, a White's Department Store was built on the site. This later became a TSS, a Modell's and then a Kmart.

Frontier City

Broadway, Route 110, Amityville • 1959–1960 • LOST

This seasonal western theme park was similar to Dodge City in Patchogue. Opening on May 30, 1959, the park was over eleven acres and made of concrete block and steel. Frank Kelly and Ray Felman of Western City Inc., who created their park after studying Disneyland and other cowboy-themed parks, headed Frontier City. This miniature town had a trading post, toyshop, corral, flower shop, general store, sheriff's office and jail and a graveyard called the Boot Hill Cemetery. The concessions operated by Bert Nathan sold hot dogs, hamburgers, soda and other refreshments, while the shops had a large number of western-themed items and other novelties. Visitors could purchase boots, moccasins, gun sets, cowboy hats, spears, charm bracelets, ceramic animals and other items. An archery range and rides cost twenty-five cents each. A Union Pacific train ran behind Boot Hill, where it was periodically ambushed by "Indians"—to the delight of visitors.

Frontier City was open every day "from High Noon to Sunset," with admission for children at fifty cents and adults at seventy-five cents. The park was seasonal and would close in early November with a gala

Musicians pose in front of the Merry Melody Shop at Frontier City while visitors inspect a hitched mule. *Collection of Gary Hammond.*

Cowboys (and one cowgirl) pose on their horses near the park's O.K. Corral. *Collection of Gary Hammond.*

festival that included shows, exhibits, half-price admissions and sales on merchandise. Twenty-two people worked at the park, including ticket attendants, six cowboys, Indians and two permanent entertainers: Cowboy Joe and Carol Phillips. The Phillipses lived at the park, and Joe

was known in the metropolitan area for his rodeo acts, while Carol was a former revue dancer.

In May 1960, Frontier City began a collaborative marketing campaign with Great Western Meat Co., a food store chain with locations in Plainview, Levittown, Hempstead, Valley Stream and Jamaica. Great Western held Wild West shows at its Jamaica and Plainview locations, with stars from Frontier City. Aside from getting roast beef at eighty-nine cents a pound and Swift TV dinners for thirty-seven cents each, shoppers could experience a stagecoach robbery and gunfights. Guests also received free barbecue and passes to Frontier City. Some of the stars who performed were Lorraine Leahy, Joker Davy Dixon and Honey Girl, Steve Reeves and the Drifters.

Advertisements listed that visitors could "be a marshal's deputy for a day of action-packed thrills in The Old West, Raid on Wells' Fargo, Boot Hill burial, Shoot-Out, Thunderbird Indians, Trick Riding, Trained Horse Act, Continuous Western Entertainment." Big on marketing and deals, Frontier City even had collaborations arranged with the Long Island Railroad so that groups could get discounted trips directly to the park. Frontier City partnered with local community groups like the Kiwanis Club of Uniondale and would bring its rodeo acts for performances supporting charities to places as far away as Albany. The marshal would deputize children each day so that the visitors could "help" with the rustlers who would surely be riding into town.

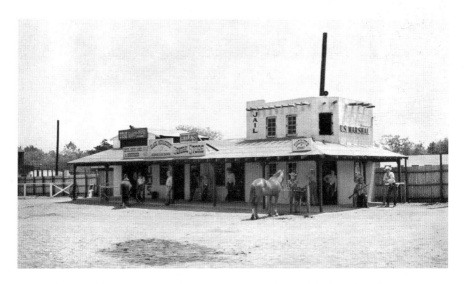

Some of the park's many costumed employees pose in front of the Frontier City Jail. *Collection of Gary Hammond.*

HISTORIC AMUSEMENT PARKS OF LONG ISLAND

Cowboys mourn in front of a grave marker that reads, "William Clairbourne, Shot by F. Leslie," in the park's Boot Hill Cemetery. Frank Leslie's grave can be seen at right. *Collection of Gary Hammond.*

There were other Frontier City parks in Michigan and Oklahoma but with no direct connection to the Amityville park aside from theme and name. The tri-state area also had many western-themed parks; there were Wild West City, Cowboy City and Frontier Village in New Jersey and Frontier Town in upstate New York. When the popularity of westerns began to decline, most of the kiddie parks closed. No mention of Patchogue's Frontier City could be found after 1960.

Turner's Amusement Park

Smithtown Boulevard, Lake Ronkonkoma • 1950–ca. 1956 • LOST

Turner's Corner Park was established by Arthur Turner in the 1920s on Lake Ronkonkoma and was a bathing pavilion with toboggan slides, diving platforms and water wheels. There was also a restaurant on the property that served alcohol during Prohibition. The park fell into disrepair during World War II and was demolished after the end of the war.

Suffolk Parks

Turner's Amusement Park opened on May 20, 1950. This kiddie park boasted a Ferris wheel, a carousel, eight kiddie rides, five concessions, a penny arcade, coin machines and games, as well as live pony rides. Near the water, the park offered bathing and a picnic grove. There was also a restaurant on the property. It was open every day from noon until midnight.

Active with the Lake Ronkonkoma community, the park held a carnival for the American Legion Auxiliary on Labor Day weekend in 1950. A few years later, in 1956, the park was still trying to support its community when three people were arrested at the park for charges of gambling. Paul Smith, manager of the park; his daughter-in-law, Barbara Smith; and a park patron were playing a game called Skillo, from which 10 percent of the profits were being given to the Cleary Deaf Child Center.

In January 1960, a local newspaper reported that the former Turner's Amusement Park was being cleared of trees and that a motel and new park would be established.

Worth Mentioning

These are parks that I came across in my research but couldn't find much information on—do you remember?

Century's 110 Drive-In

Broadhollow Road, Melville • 1956–1977

Kiddieland
Carousel, miniature railroad, chair ride, swings and slides

Happy Town

Jericho Turnpike, Commack • 1954

Seven rides

Mullers City of Fun

Montauk Highway, Hampton Bays • 1980s

Conclusion
KIDDIE AMUSEMENTS TODAY

Much has changed in the kiddie amusement industry in the last seventy years. Independently owned and family-run parks can no longer survive in a world that seems to require constant stimulation, new technology and accessibility. While many families make vacations out of visits to the large corporate theme parks like Disney World and Hershey Park, there still are some local options for Long Islanders today.

There are many corporate venues with more than one location. The **Chuck E. Cheese** franchise first opened in 1977 in San Jose, California, and was originally called Chuck E. Cheese's Pizza Time Theatre. Nolan Bushnell, the Atari co-founder, first came up with the idea for the restaurant. There are almost six hundred restaurants today. On Long Island, there are locations in Brooklyn, Flushing, Long Island City, Hempstead, Hicksville, Commack, Patchogue and West Islip. Chains like **Dave and Busters** have arcade games, bowling alleys and full-service restaurants. David Corriveau and James "Buster" Corley opened their first location in Dallas, Texas, in 1982. Today, there are over seventy locations throughout the country. On Long Island, there are locations in Westbury, Farmingdale and Islandia. **BounceU** stores first opened in 2003 and are popular for children's birthday parties with their inflatable equipment and arcade games. On Long Island, there are locations in Brooklyn, College Point, Oceanside, Farmingdale and Smithtown.

One Long Island–based operation is **Fun Station USA**. These restaurants and entertainment sites have full arcades, as well as rides and games like

Conclusion

Maya Hollywood Krulder reaches for the ring at the restored Nunley's Carousel at the Cradle of Aviation in Museum Row, Garden City. *Author's collection.*

carousels and miniature trains—all indoors. The only Long Island location is in Lynbrook. The unifying factor with these newer amusement facilities is that the majority (if not all) of their activities are indoors, which enables them to operate year round. Gone are the days of rain equaling lost business for parks; instead, bad weather now brings even more business to these operations.

There are some places that primarily function as outdoor amusements, however. **Splish Splash Water Park** in Calverton opened in 1991. The original owners were the same as those of Adventureland in Farmingdale. In 1999, the owners sold it to Palace Entertainment, a California-based company that owned thirty-one other family parks in eight states. MidOcean Partners, a private investment firm, then purchased the park in 2006. This ninety-six-acre park is still in operation and has over thirty water rides and a restaurant. While the park is for all ages, there is a separate kiddie area called Kiddie Cove. Other seasonal parks have indoor facilities like arcades and laser tag. **Tiki Action Park** in Centereach has a go-kart track and a miniature golf course. **Boomers!** parks have locations in California and Florida and one on Long Island in Medford that opened in 1999. This park originally opened under the name **Bullwinkle's Family Food 'n' Fun Park** by the same group that owned Adventureland and Splish Splash. The

Conclusion

park today has go-karts, miniature golf, batting cages, an arcade and even a water ride called Bumper Boats. Boomers! also has some classic kiddie rides like a carousel, a roller coaster, teacups, jets and kiddie swings. There are also large facilities like **Country Fair: Family Amusement Center & Restaurant** on Route 112 in Medford and **Bayville Adventure Park** on the Long Island Sound, which have been around a few decades but have had numerous owners and constant updates.

For those who want their children, grandchildren or even themselves to have more of a traditional kiddie park experience like they once had, there are only *three* parks covered in this book that are still in operation: **Adventurers Family Entertainment Center** in Bensonhurst, **Deno's Wonder Wheel Park** in Coney Island and **Adventureland** in Farmingdale. Otherwise, remnants of lost parks do exist in some cases in the form of their carousels.

Brooklyn

The **Prospect Park Carousel** is a circa 1914–16 Mangels/Carmel classic wood carousel that first operated in Coney Island until it was moved to its current location in 1952. A 1919 Mangels/Carmel **B&B Carousell** is the last operating carousel at Coney Island. It operated in Bertrand Island in Lake Hopatcong, New Jersey, until 1932 before moving to Coney Island until 2005, when it went into storage. The carousel reopened in 2013, and today it operates in Steeplechase Plaza on the boardwalk. The DUMBO section of the Brooklyn Bridge Park has housed a 1922 PTC #61 carousel since 2011. Originally operated in Idora Park in Youngstown, Ohio, this classic wood carousel is listed on the National Register of Historic Places and is known as **Jane's Carousel**.

Queens

The 1903 **Forest Park Carousel** is one of two D.C. Muller Brothers carousels that are still in operation. It was originally at Lakeview Park in Dracut, Massachusetts, until 1971, when it moved to Queens to replace a carousel that was lost in a fire. The carousel was closed in 2009 when its

Conclusion

vendor contract expired. The local community started numerous campaigns and petitions to reopen the carousel, and finally, in 2012, a new vendor was awarded a contract. It received a New York City Landmark designation in 2013. There is a 1903–08 Mangels/Illions carousel in operation at Fantasy Forest in **Flushing Meadows–Corona Park**. The classic wood carousel is the merger of two carousels from Coney Island. The first opened as Feltman's Carousel in 1903, while the second first operated in 1908 as the Stubbman's Beer Garden Carousel. The two carousels were merged and moved to Flushing Meadows–Corona Park for the 1964 New York World's Fair. It has remained in the park, where it is still in operation, having closed only for restoration.

Nassau

As discussed in Chapter 3, the 1912 Stein and Goldstein **Carousel from Nunley's** Amusement Park in Baldwin began its life in Golden City Park in Canarsie, Brooklyn. It has been in operation at the Cradle of Aviation Museum in Garden City since 2009. The **Heckscher Carousel** in Hempstead Lake State Park, West Hempstead, was designed by M.C. Illions around 1914. Philanthropist August Heckscher donated the carousel to the park in 1931, and it has remained there ever since. It was restored in 2004, with its building undergoing renovations in 2005.

Suffolk

A 1920 Herschell-Spillman Carousel is operating at **Mitchell Park** in Greenport. This carousel operated at the Grumman's picnic grounds in Calverton from the 1950s until it was donated to the Town of Greenport and moved to its current home in 1995.

We have loved and lost many amusement parks across Long Island. Hopefully this history of these beloved places brings happy memories of another time and reminds us to cherish the sites we still have with future generations of Long Island's children.

NOTES

Introduction

1. Hillman, *Amusement Parks*, 38.
2. *New York Times*, August 4, 1929.
3. Griffin, *Step Right Up Folks!*, 21.
4. *Billboard*, "Vet's Multiple Offspring Give Banner Biz to McKee, Gruberg Long Island Moppet Centers," August 12, 1950
5. Ibid., April 9, 1949.
6. Ibid.
7. *Newsday*, June 6, 1958.
8. Irwin Kirby, "Ops Differ on Mixing Major, Small Rides," *Billboard*, April 9, 1955, pp. 51, 71.
9. Griffin, *Step Right Up Folks!*, viii.

Chapter 2

10. *New York Times*, "Monkey Is Hunter as Ice Box Raider," October 28, 1936.
11. *Billboard*, "Fire Damages Shop, Coaster at Fairyland," November 25, 1957.
12. *New York Times*, "Play Park Safe Stolen," June 1, 1959.

Notes

Chapter 3

13. *New York Times*, "Cheetah Twins Are Born," February 23, 1936.
14. Ibid., "Buck Gets New Animals," May 25, 1936.
15. Ibid., "Jungle Germ Harries Buck," September 8, 1936.
16. Ibid., "Horse Kicks Frank Buck," October 19, 1936.
17. Ibid., "Python Bites Frank Buck," July 5, 1938.
18. Ibid., "150 Monkeys Flee Camp, Stop Train," August 22, 1935.
19. Ibid., "Fugitive Monkeys Frolic at Fair," July 12, 1939.
20. *Newsday*, "Oh for the Jungle Cry Ration-Hit Animals at Massapequa," November 13, 1942.
21. Ibid., "All Together, Now Scream," July 16, 1972.
22. *Billboard*, "Nelson Preps New Kid Unit in Jersey," July 5, 1952.
23. *Newsday*, August 27, 1972.
24. Ibid., "Farm's Fate: Baa-Baa Here, Bye-Bye There," January 18, 1967.
25. *Bethpage Tribune*, "Should Pony Express, Railroad Be Halted Near Yonder Pass?" November 17, 1966.
26. *Newsday*, 1967.
27. Ibid., "Happyland Horses Find New Turf," November 22, 1978.
28. *New York Times*, "Freeport's 'Vamps' Quit Film Star Flat," June 29, 1931.
29. Ibid., July 4, 1964.
30. *Newsday*, "Amusement Center Uses Space Theme," June 17, 1958.
31. *Billboard*, "Space Grotto Best in Ne Kid's Park," June 30, 1958, 54.
32. Ibid., "TV Mentions Up Turnouts at Spaceland," May 18, 1959, 50.
33. *New Yorker*, "Murray the K's World," April 16, 1966.

Chapter 4

34. *Newsday*, "Ferris Wheel Spills 3; Girl, 2, Critically Hurt," June 29, 1964; *New York Times*, "Girl, 2, Dies After Fall From L.I. Ferris Wheel," June 30, 1964.

BIBLIOGRAPHY

Bakken, Gordon Morris, and Brenda Farrinton, eds. *Encyclopedia of Women in the American West*. Thousand Oaks, CA: Sage Publications Inc., 2003.

Bookbinder, Bernie. *Long Island: People and Places Past and Present*. New York: Harry N. Abrams, Inc., 1983.

Brady, Ralph F. *Landmarks and Historic Sites of Long Island*. Charleston, SC: The History Press, 2012.

Caro, Robert A. *The Power Broker: Robert Moses and the Fall of New York*. New York: Vintage Books, 1975.

Denson, Charles. *Images of America: Coney Island and Astroland*. Charleston, SC: Arcadia Publishing, 2011.

Fiore, Roberta, Carole Shahda Geraci and Dave Roochvarg for the Long Beach Historical and Preservation Society. *Images of America: Long Beach*. Charleston, SC: Arcadia Publishing, 2010.

Fortunato, Claudia S. "Historic HHH: Fairyland Amusement Park." *Half Hollow Hills Patch*, August 21, 2011.

Bibliography

Frommer, Myrna Katz, and Harvey Frommer. *It Happened in Brooklyn: An Oral History of Growing Up in the Borough in the 1940s, 1950s, and 1960s.* Albany: State University of New York Press, 2009.

Futrell, Jim. *Amusement Parks of New York.* Mechanicsburg, PA: Stackpole Books, 2006.

Gottlock, Barbara, and Wesley Gottlock. *Lost Amusement Parks of New York City: Beyond Coney Island.* Charleston, SC: The History Press, 2013.

Griffin, Al. *Step Right Up Folks!* Chicago: Henry Regnery Company, 1974.

Guarino, Liz, and Dan Guarino for the Broad Channel Historical Society. *Images of America: Broad Channel.* Charleston, SC: Arcadia Publishing, 2008.

Hahner, David P., Jr. *Images of America: Kennywood.* Charleston, SC: Arcadia Publishing, 2004.

Hillman, Jim. *Amusement Parks.* Long Island City, NY: Shire Publications, 2013.

Hirsh, Rose Ann. *Images of America: Western New York Amusement Parks.* Charleston, SC: Arcadia Publishing, 2011.

Immerso, Michael. *Coney Island: The People's Playground.* New Brunswick, NJ: Rutgers University Press, 2002.

Kasson, John F. *Amusing the Millions: Coney Island at the Turn of the Century.* New York: Hill and Wang, 1978.

Krieg, Cynthia J., and Regina G. Feeney. *Images of America: Freeport.* Charleston, SC: Arcadia Publishing, 2012.

Larson, Erik. *The Devil in the White City: Murder, Magic, and Madness at the Fair that Changed America.* New York: Vintage Books, 2004.

Lehrer, Steven, ed. *Bring 'Em Back Alive: The Best of Frank Buck.* Lubbock: Texas Tech University Press, 2000.

BIBLIOGRAPHY

Lightfoot, Frederick S., Linda B. Martin and Bette S. Weidman. *Suffolk County, Long Island in Early Photographs, 1867–1951*. Mineola, NY: Dover Publications, 1984.

Lucev, Emil R., Sr. *Images of America: The Rockaways*. Charleston, SC: Arcadia Publishing, 2007.

Mercaldo, Christopher. *Images of Modern America: Adventureland*. Charleston, SC: Arcadia Publishing, 2014.

Oswald, Keith, and Dale Spencer. *Images of America: Lake Ronkonkoma*. Charleston, SC: Arcadia Publishing, 2011.

Seyfried, Vincent F., and William Asadorian. *Old Queens, N.Y. in Early Photographs*. Mineola, NY: Dover Publications, 1991.

Suffolk County Organization for the Promotion of Education, ed. *Where to Go and What to Do on Long Island*. Mineola, NY: Dover Publications, 1993.

Weidman, Bette S., and Linda B. Martin. *Nassau County Long Island in Early Photographs, 1869–1940*. Mineola, NY: Dover Publications, 1981.

Wojtas, Gary W. *Long Island: Yesterday & Today*. Lincolnwood, IL: Publications International, Ltd., 2010.

Woods, Richard. *Images of America: Oceanside*. Charleston, SC: Arcadia Publishing, 2004.

INDEX

A

Adventureland 9, 65, 66, 67, 126, 127, 133
Adventurers Family Entertainment Center 127
Adventurers Inn 7, 13, 18, 41, 42, 66
Alberts, Carol Hill 38
Alberts, Dewey 37
Alberts, Jerry 37
Amityville 69, 119, 121, 122
Astroland 7, 36, 37, 38, 131
Astrotower 37, 38
Atom Smasher 52
Auer Midway Park 46
Auer's 7, 45, 46, 47
Auer, William 45

B

Baldwin 13, 58, 61, 88, 92, 93, 94, 96, 97, 102, 117, 128
Bay Shore 111
Bay Shore Amusement Park 111
Bayville Adventure Park 127
B&B Carousell 127
Beall, Charles W. 69
Bensonhurst 7, 27, 28, 127

Bethpage 18, 58, 61, 94, 97, 100, 117
Black, Bob 56
Bly, Nellie 27, 28, 29, 31
Boomers! 126
BounceU 125
Brighton Kiddie Park 38
Broad Channel 7, 58, 59, 61, 97, 117, 132
Broad Channel Amusements 59
Buck, Frank 67, 69, 70, 71, 72, 132
Budin, Herb 65
Bullwinkle's Family Food 'n' Fun Park 126

C

Canarsie 7, 21, 25, 91, 128
Carle Place 105
Carmel 91, 127
carousel 14, 21, 23, 26, 27, 28, 31, 34, 36, 37, 41, 42, 46, 49, 54, 55, 57, 58, 59, 61, 64, 65, 72, 75, 79, 88, 90, 91, 93, 94, 95, 96, 97, 99, 100, 103, 111, 115, 117, 123, 127, 128
Century's 110 Drive-In 123
Chicago World's Fair 15

INDEX

Chuck E. Cheese 125
Cinderella Kiddie Park 64
Cohen, Alvin 65
Coney Island 7, 14, 15, 21, 26, 27, 32, 34, 35, 36, 37, 38, 43, 44, 45, 55, 58, 73, 91, 92, 93, 99, 104, 127, 128, 131, 132
Country Fair 127
Cowboy City 122
Cross Bay Amusement 7, 61, 62
Curran, John 34
Cyclone 31, 34, 37

D

Dave and Busters 125
Davis, Leo 21, 115
Deno's Wonder Wheel Park 32, 35, 127
Dentzel 65, 93, 97, 99
Disney World 125
Dodge City 12, 13, 112, 113, 119
Douglaston 7, 55
Dreamland 15, 21, 38, 56, 57, 73

E

Elmhurst 7, 47

F

Fairyland 7, 12, 13, 21, 25, 47, 49, 52, 115, 117, 131
Fairytown, USA 116
Fantasy Forest 128
Farmingdale 9, 65, 77, 125, 126, 127
Feinberg, Roy 114
Felman, Ray 119
Feltman, Charles 36
Feltman's 36, 37, 128
Ferris, George 15
Ferris wheel 32, 57
Finkel, Bob and Bernie 102
Flight to Mars 44
Flushing 7, 13, 18, 26, 32, 41, 44, 70, 75, 94, 125, 128
Flushing Meadows-Corona Park 26, 32, 44, 128

Forest Park Carousel 127
Frank Buck's Jungle Camp 67, 69, 72
Freeport 88, 90, 99, 101, 102, 132
Frontier City 119, 121, 122
Frontier Village 122
Fun Fair Park 41
Fun Forest Amusement Park 44
Fun Station, USA 125

G

Gagnon's Kiddie Park 109
Garden Amusements 12, 19, 78
Garden City Park 19, 78, 81
Gardeners' Village 109
Garms, Herman 32, 35
Garto brothers 37
Gaslight Village 44
Geist, A. Joseph 52
Gentile, Tony 67
Golden City Park 91, 128
Grant's Department Store 109
Great Adventure Amusement Park 7, 41
Grimaldi 72
Gruberg Funland 72
Gruberg, Max 39, 56, 74
Grugberg's Playland 72

H

Hadfield, Murray 102
Handwerker, Murray 103, 105
Handwerker, Nathan 36, 103
Happyland 18, 58, 61, 94, 96, 97, 130
Happy Town 123
Heckscher Carousel 128
Herschell 18, 21, 44, 49, 54, 55, 64, 65, 88, 94, 105, 117, 128
Hershey Park 16, 125
Howard Beach 7, 61, 62
Huntington 113, 115
Hurricane Sandy 27, 62, 77

I

Illions 91, 93, 128

INDEX

J

Jane's Carousel 127
Jazzbo 102, 104
Jolly Rogers 18, 94, 98
Joytown 7, 47, 52

K

Kaufman, Murray "Murray the K" 108
Kelly, Frank 119
Kennywood Park 16
Kiddie Funland 77
Kiddie Haven 78, 80
Kiddie Park, Fresh Meadows 7
Kiddy City 7, 55, 56

L

Lake Ronkonkoma 122, 123, 133
Lander, Max 41, 42, 97
Lange, Joe and Anne 63
L.A. Thompson Amusement Park 45
Lercari brothers 93
Lercari, Lou 96
Lewis, Joe and Sarah 63
Lollipop Farm 82, 84, 86, 87, 88
Long Beach 11, 26, 56, 57, 72, 74, 75, 77, 102, 103, 104, 105, 114, 131
Looff, Charles 91
Loveland, T.A. 69
Luna Park 15, 21, 38

M

Macdonald, C.C 16
Mangels 19, 44, 49, 91, 103, 117, 127, 128
Massapequa 67, 69, 70, 72
Massapequa Zoo and Kiddie Park 67, 72
McCullough, James (Jimmy), III 27
McCullough, James, Jr. 26
McCullough, Leonard and George 26
McCullough's 26, 27
McGinnis's 12, 19, 78, 80, 81
McKee, Alfred 51

Michaels, Lionel "Mike" 105
Middle Island 116
Mid-Island Plaza 109
Midway Kiddie Park 64
Miller, Irving 21, 25, 115
Miller, William 66
Mitchell Park 128
Moses, Robert 15, 26, 47, 52, 82, 101
Mullers City of Fun 123
Museum Row in Garden City 93
Myerberg, Michael 107

N

Nathan's Famous 36, 104, 105
Nelson, Arthur 78
1964 New York World's Fair 44, 128
1939 New York World's Fair 32, 82, 94
Nunley, Miriam 41, 61, 97, 117
Nunley's 7, 11, 13, 18, 47, 58, 59, 61, 88, 90, 91, 93, 94, 96, 97, 117, 128
Nunley's Rockaway Beach 59, 97
Nunley, William 58, 59, 61, 88, 93, 94

O

Oceanside 69, 102, 103, 104, 125, 133
Ozone Park 7, 63

P

Palisades Amusement Park 44
Park Playland Center 7
Patchogue 13, 112, 119, 122, 125
Peter Pan 31, 32
Pinsky family 80, 81
Platt, Ted 12, 19, 80
Playland Center 61
Playland Park 99, 101, 102
Prospect Park Carousel 127

R

Roadside Rest Kiddieland 102
Rockaway 7, 14, 45, 46, 47, 52, 55, 58, 59, 61, 64, 97, 117

Index

Rockaway Beach 7, 45, 46, 47, 52, 53, 58, 59, 64, 97
Rockaways' Playland 7, 41, 45, 52, 54, 59
Romano, Alfred and Henry 27
Romano, Gene 31
Roosevelt Field 77, 105, 109

S

Sadowski, Frank 38, 57
Schiff 51, 61, 88, 94, 97, 117
Seyman, Albert 38, 57
Sheepshead Bay 31, 32, 80
Shor, Leon 102
Simon, Dave 55, 56
Society for the Preservation of Long Island Antiquities 88
Spaceland 105, 106, 107, 108
Splish Splash 9, 126
Steeplechase 15, 21, 26, 45, 55, 127
Storyland Village 84, 117
Stubbman's 128
Sunset Beach 47
Sweeny, Alice 86
Sweeny, Harry 82, 86
Syosset 82, 85, 89

T

Tester, Edmund A., Sr. 104
Tiki Action Park 126
Tobin, Lester 105, 107
Turner, Arthur 122
Turner's Amusement Park 122, 123

U

Utica Funland 39

V

Vourderis, Deno 34

W

Ward's 32, 34
Warhol, Andy 108
Wild West City 122
Wohlman, Irwin 114
Wonderland 7, 36, 37, 39, 63, 64, 75
Wonder Wheel 32, 34, 35, 38, 127

ABOUT THE AUTHOR

Marisa L. Berman is a historian and nonprofit professional and has worked at numerous museums and cultural institutions across Long Island and New York City, including the Harriet and Kenneth Kupferberg Holocaust Resource Center & Archives, the Queens Historical Society and the Nassau County Museum Division. She has conducted numerous speaking engagements throughout New York on various aspects of local history. Berman is currently pursuing a doctorate at St. John's University.

Courtesy of Christie Farriella.

Visit us at
www.historypress.net

This title is also available as an e-book